Christmas Postcards

Robert M. Reed

Other Schiffer Books by Robert Reed
Advertising Postcards
Greetings from Ohio: Postcards 1900-1960s
Greetings from Pittsburgh

Other Schiffer Books on Related Subjects
Angel Collectibles. Debra S. Braun
Christmas 1940-1959. Robert Brenner
Christmas 1960 to the Present. Robert Brenner
Christmas Jewelry. Mary Morrison
Christmas Long Ago. Marian I. Doyle
Christmas Ornaments: A Festive Study. Margaret Schiffer
Christmas Past. Robert Brenner
Christmas Plates. Lars Christoffersen
Christmas Revisited. Robert Brenner
Christmas Through the Decades. Robert Brenner
Christmas Tree Pins O Christmas Tree. Nancy Yunker Trowbridge
Holiday Toys and Decorations. Margaret Schiffer
Kitchmasland! Christmas Decor from the 1950s through the 1970s. Travis Smith
Nativity Creches of the World. Leslie Piña & Lorita Winfield
Snow Babies, Santas, and Elves: Collecting Christmas Bisque Figures. Mary Morrison

Copyright © 2007 by Robert M. Reed
Library of Congress Control Number: 2007930468

Covers and book designed by: Bruce Waters
Type set in Zapf Chancery Bd BT/New Baskerville BT

ISBN: 978-0-7643-2689-9
Printed in China

Published by Schiffer Publishing Ltd.
4880 Lower Valley Road
Atglen, PA 19310
Phone: (610) 593-1777; Fax: (610) 593-2002
E-mail: Info@schifferbooks.com

For the largest selection of fine reference books on this and related subjects, please visit our web site at **www. schifferbooks.com**
We are always looking for people to write books on new and related subjects. If you have an idea for a book please contact us at the above address.

This book may be purchased from the publisher.
Include $3.95 for shipping.
Please try your bookstore first.
You may write for a free catalog.

In Europe, Schiffer books are distributed by
Bushwood Books
6 Marksbury Ave.
Kew Gardens
Surrey TW9 4JF England
Phone: 44 (0) 20 8392-8585; Fax: 44 (0) 20 8392-9876
E-mail: info@bushwoodbooks.co.uk
Website: www.bushwoodbooks.co.uk
Free postage in the U.K., Europe; air mail at cost.

Contents

Introduction

What a quiet joy, the old Christmas postcard, a tangible record of yuletides past, a glimmer of mistletoe or a stately Christmas tree with brightly burning candles. Other aging cards reveal beaming children or Santa.

These are all images first looked upon a century ago.

They were purchased by family and friends. Eagerly they were dispatched to those loved ones near and far away. They sent warm wishes for the holiday.

Often there were hand-written messages on the back of the postcard. Today historians consider them contemporaneous records. Diary-like notes of feelings from common folk as that special day neared.

The images on the front were a reflection of how special it was mean to be in each American household. A little idealized maybe, but the mood was clearly there, succinctly captured on a simple, yet elegant postcard.

Once upon a time there were lots of Christmas postcards.

During the first quarter of the twentieth century, hundreds and hundreds were produced by a host of publishers. The vast majority of Christmas postcards were mailed. For a time, lots of people treasured and saved them.

In this volume we present hundreds up hundreds of them for the reader. Most are in excellent condition; however, a few may be slightly weathered from the trek over the river and through the woods with the postal carriers and from the longer trip through time.

Together they are the purest essence of Christmas Past.

Early 1900s; $4-5.

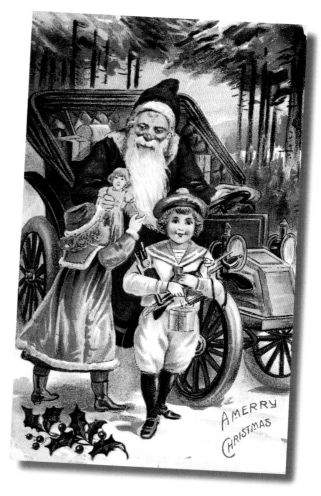

Undated; $5-7.

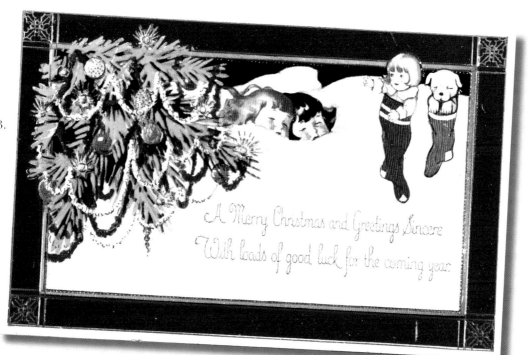

Circa 1908; $2-3.

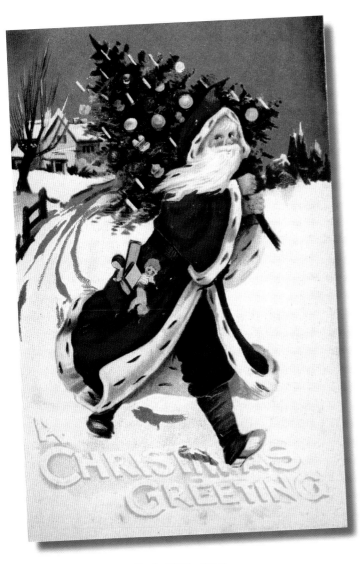

Early 1900s; $6-8.

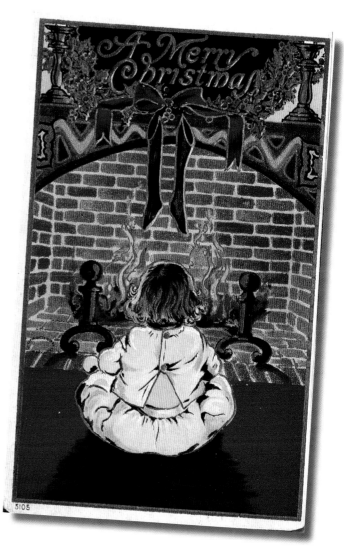

undated; $3-4.

A Brief History

Christmas cards, whether sent as postcards or enclosed as letters, are responsible for much of the universal goodwill and happiness of Christmas Day.
– *The Christmas Book*
Jane Stewart, 1908

In the world of Jane Stewart and her writings, the Christmas postcard was very fascinating and very fashionable. It would be so for the next few decades before other Christmas messages took its place. However, the rise of the Christmas postcard in America actually began much earlier in another land.

Starting in the 1840s, British publishers began combing the "new" art of lithography and hand coloring to produce a rudimentary Christmas card. Initially they were small, comparable to the size of a business card today. Most carried nothing more than a simple inscription saying Merry Christmas and Happy New Year.

Gradually, larger and more colorful cards were put into use. Landscapes, birds, and even holly branches were added to the basic greetings. As early as the 1880s, the practice had gained a limited popularity in the United States. However, since such greetings required envelopes, the practice in the States was expensive. Moreover, the mail service remained relatively slow and undependable.

Even so, by the 1890s the demand for Christmas cards in America had steadily increased. European printers, especially those in lithographically advanced Germany, began to envision the growing potential of the American market. Nor did it go unnoticed in progressive England when the Christmas card idea had begun. There the master of such greetings was Raphael Tuck and Company (later Raphael Tuck and Sons). Early on, Tuck had been designing Christmas cards for the British royal family. And they were not skimpy white cards with a few terse words. They were large, sometimes twenty-three by fifteen inches, and colorful too.

Of course the royal family spared little expense as well. Often the Christmas cards were enclosed in cases of white leather lined with silk. They were then stamped with the royal monogram in gold.

In the midst of all the grandeur came the trade card. Almost in contrast to the splendid Christmas card, the trade card had sort of grown up on the wrong side of the tracks. It had made an appearance earlier in the nineteenth century in simple black and white form. Their task was mainly just to identify and locate the merchant's place of business.

But the blessing of lithography also changed the course of the trade card.

Toward the latter part of the nineteenth century it was apparent that bright colors could be produced on such cards in a relatively inexpensive means. Some were said to be so well done they even rivaled oil paintings.

Like their counterpart, the Christmas card, even the lavish coloring was at first used sparingly. Almost any full-color image could pass as a Christmas trade card. All it needed was some sort of holiday greetings included on the face of it. Happy and smiling children were great, but sledding scenes, or even various birds and animals for fully accepted as holiday fare. Initially only a number of vintage Christmas trade cards featured what would later be considered traditional symbols such as holly, mistletoe, the Nativity, and either Father Christmas or Santa.

Here in the United States late in the nineteenth century such holiday trade cards varied in size. Most were two or three inches wide and four or five inches deep. That made them just right to fit into the pocket or purse. Other types, however, could be as large as seven or eight inches tall, or as small as a few inches square.

But all were finally, brilliantly colorful. Moreover they were handed out free to customers. In some cases, but not all, the merchant's name was discreetly stamped on the reverse of the image. In other situations it was the name of the product that was featured. At other times just the colorful image and a brief yuletide greeting was enough, and no advertising was included.

As the Christmas trade cards grew more numerous, likewise they became more seasonal. It might be a beautiful child wearing a holly wreath from Lion Coffee, or a red-suited Santa on a card from the Woolson Spice Company. The N. K. Fairbanks Company went so far as to have a Santa Claus Soap for the season, complete with a Santa carrying a Christmas tree on their trade cards. And for the record, the trade card Santa could be just as varied as the Santa postcards later would be. Santa might be wearing a fur-trimmed hood or a pinecone cap. His outfit could be blue, brown, white or finally the prevailing red.

Then, as fate or history would have it, both the pre-

existing Christmas card and the delightful Christmas trade card began to be overshadowed by a tiding known as the postcard.

Basically the postcard idea had been around for decades.

European countries, including England became fairly adept at producing them in various forms during the nineteenth century. In the United States, however, the federal government restrained private companies from fully pursing postcards. There was an official government Postal Card with the postal stamp imprinted upon its surface.

By 1901, the U.S. government had relented somewhat. Private companies could print postcards and even use the name postcard on the back. However, nothing more than the address of the recipient was allowed on the back. No personal messages were allowed. Certainly no hand-written greetings were permitted. Only the basic address could occupy the wide-open spacious reverse of the card.

More federal government modification comes in 1906 and afterwards the so-called divided back came into vogue. Here a thin black line was applied to allow for the address on the right and a brief hand-written or printed message on the left. The revolution had begun.

Writing in 1908, Jane Stewart saw the transformation:

> The Christmas card has been given the postal-card form by placing the outline for the address and the postage stamp on its back. In this way it has became even more firmly established in hearts of the people, and given even wider extension.

The kinship was sometimes obvious. An early 1900s Christmas postcard complete with a kindly Santa Claus bore a message from a general store in Fremont, Kansas. Printed in red ink on the reverse side was this:

> Bring this card to our store during the Holidays, and you will receive our latest household convenience, a beautiful Calendar combined with a Weekly Kitchen Reminder. We have a full line of seasonable specialties that will please you.

It was signed by Landgren & Person. It also included the image of a can of Calumet Baking Powder.

Trade card
Circa 1880s; $2-3.

Trade card
Circa 1880s; $3-4.

Trade card with poem to Father
Christmas on reverse
Circa 1880s; 3-4.

Trade card with poem to Bright
Christmas-Tide on reverse
Circa 1880s; $4-5.

8

Lion Coffee trade card from
Woolson Spice Company
Circa 1890s; $4-5.

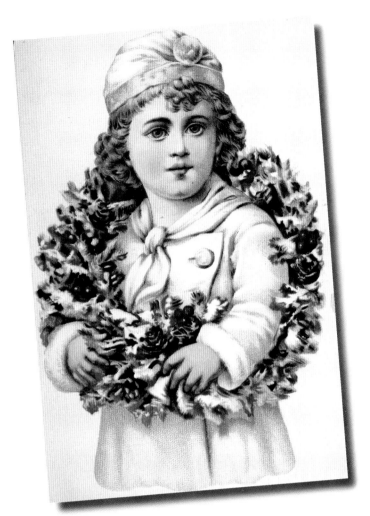

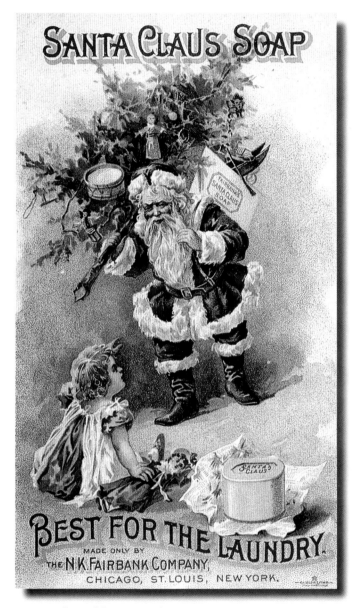

Trade card for Santa Claus Soap
Circa 1890s; $30-40.

Trade card from Woolson
Spice Company
Circa 1890s; $2-3.

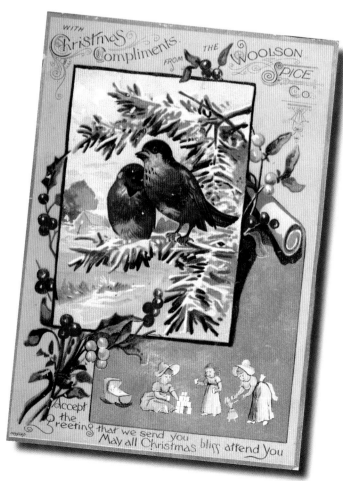

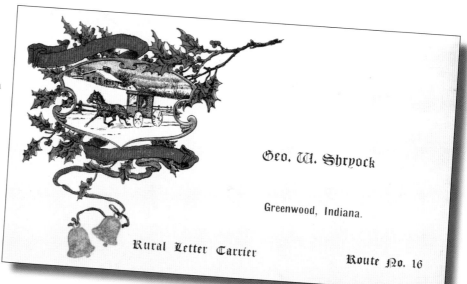

Rural carrier Christmas card with
Christmas poem in reverse
Circa 1900s; $3-4.

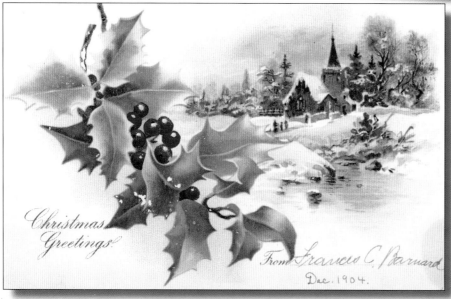

Posted 1904; $1-3.

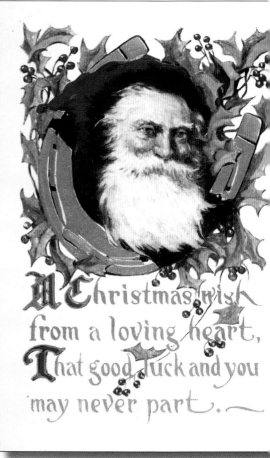

General Store premium
offer on reverse
Circa 1900s; $5-6.

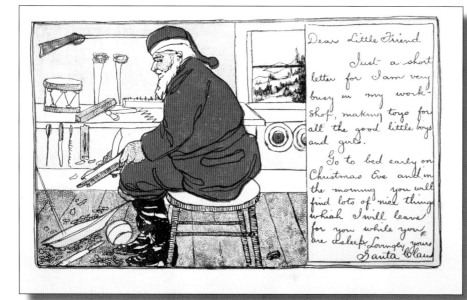

Circa early 1900s; $4-5.

10

The Santa Selection

We shall have an old-fashioned Christmas,
And I myself intend to dress up as Santa Claus
for the children. If my influence goes for
aught in this busy world, I hope that my example
will be followed in every family in the land.
 – President Benjamin Harrison, 1891

Santa Claus, among many other things, is an intriguing paradox. Everyone knows what Santa Claus looks like. Then again, no one really knows what Santa looks like.

Santa is of course a figure of myth and imagination and not of flesh and blood. Not surprisingly, therefore, he appeared on early Christmas postcards in all manner of forms, and wearing equally assorted costumes.

If President Harrison did indeed dress up like Santa Claus for that wonderful Christmas of 1891, his costume was very likely styled in keeping with the works of nationally known cartoonist Thomas Nast. The Nast version of Santa—as often then seen in *Harper's Weekly*—was plump and jolly. The popular editorial cartoonist presented his readers with a kindly gent wearing a cap trimmed in fur, usually with a bag of presents on his back.

It is important to note how much influence the German-born artist drawing for readers in the 1860s, 1870s, and 1880s bore later on Christmas postcards. It was Nast who had Santa living at the North Pole and spending most of his time making toys. Nast's Santa also kept a book or ledger to account for good and bad children. Nast's Santa also cheerfully interacted with children and was eventually even depicted talking to them on the telephone.

Sure, Clement Moore's famous poem "A Visit From St. Nicholas" was published and illustrated earlier in the 1830s. The accompanying drawings by United States military academy professor Robert Weir did indeed give Santa the costume and the bag of presents, and even the sleigh. But a large measure of the Santa illustrations on early twentieth century Christmas postcards were very, very much in the style of Thomas Nast.

Still they were not all drawn from Moore or Nast.

Legendary British postcard producer Raphael Tuck and Sons, for example, drew from many images of Santa. Instead of the traditional red suit, Tuck's Santa might be clad in blue, green, gold, brown, or even white. Instead of a suit, the postcard illustration may put Santa in a robe, or pants and a matching jacket, or in pants and a contrasting jacket.

While a majority of early twentieth century offerings leaned the Nast way, the variations on Christmas postcards were almost endless. In some postcards Santa might be wearing a purple hat while surrounded by toys. Perhaps a more regal Santa might be wearing a gold hat decked with pinecones. On other postcards, Santa might be virtually bare headed. Like the Moore' poem, he might be depicted smoking a pipe. Elsewhere, Santa might be smoking a cigar or sipping from a glass of champagne.

Santa settings could vary too. He could be going over the ledger in his shop, or just happily making toys. He might be found peering into the window of a house, or smiling from in front of the fireplace.

Transportation could be a factor in these early Santa postcards too. He might be just trudging along in the snow on foot, or riding in the traditional sleigh. He might have a bag of toys with him, a pair of ice skates, or a fully decorated Christmas tree. Then too he could be aboard an airship or even in the cockpit of that marvelous aeroplane invention. In more extreme cases, Santa could be bounding along at the wheel of an automobile, or mastering a motorbike. Then too Santa could be riding on the back of an animal, or soaring in the sky aboard a hot air balloon.

What about emotions? Santa could have a beaming smile, or be stern-faced. He could be depicted on the postcards as kindly and generous, or nearly scary and threatening. One version had a grim looking Santa actually gathering up children (apparently misbehaving ones) in a bag, seemingly preparing to take them away.

The context in which Santa appeared on early Christmas postcards therefore could vary considerably. And the scarcer the variations are generally, the more collectible and sought after the Santa postcards.

Even beyond the basic Santa postcard, there were more elaborate versions. Manufacturers offered hold-to-light cards, die-cut mechanical cards where a dial was turned to change the Santa scenery, and so-called installment cards. With installment cards, images were provided in ordinary postcard form periodically, and all the cards put together then formed an even larger Santa picture.

Briefly, there was also Santa postcards decorated in a powder-like glitter to make them more appealing. The glitter brought complaints from postal workers, however, who claimed it came off on their hands and

was harmful. Postal authorities for a time even consider charging double the postal rate for such glitter-covered postcards.

Still higher on the scarce Santa postcard scale would be those showing children dressed as Santa, a female Santa, or black Santa. All were produced at one time. Perhaps even scarcer are those depicting America's own Uncle Sam as Santa Claus.

Typically, the more unusual Santa's demeanor, costume, and means of transportation, the more the postcard is prized. Moreover, the more out of the ordinary the character in the Santa outfit, the greater the demand.

But have no doubts. Standard smiling Santa fare or somber and stately Santa selections are all collectible. And, for the record, the Santa image most likely to be conjured up today is probably something like the Coca-Cola® version rendered by artist Haddon Sundblom. It was Sundblom who was famous for holiday scenes and for Coke advertisements with jolly Santa. In fact many experts think Sundblom's Santa looked very much like his own smiling and beaming self.

At any rate the Coke Santa came along the 1930s, long after most Christmas postcards had become history (an exception appears in this chapter).

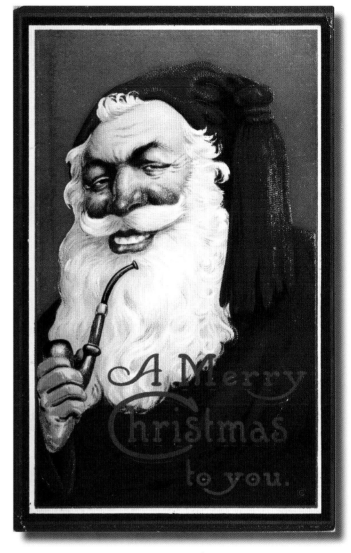

Posted 1915; $8-10.

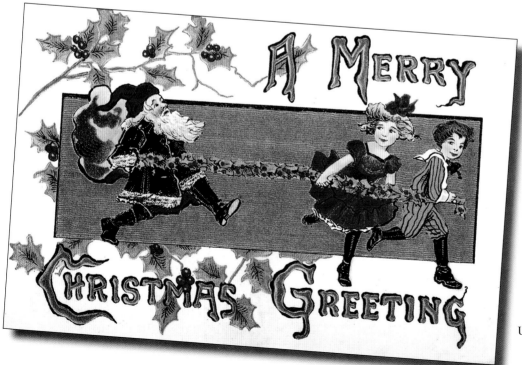

Undated; $9-11.

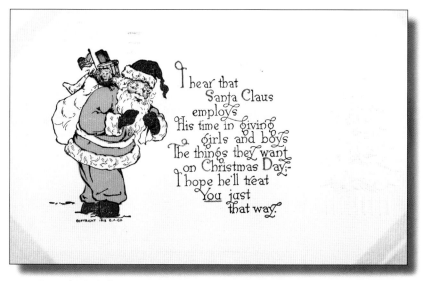

I hear that Santa Claus employs His time in giving girls and boys The things they want on Christmas Day; I hope he'll treat You just that way.

Posted 1913; $4-5.

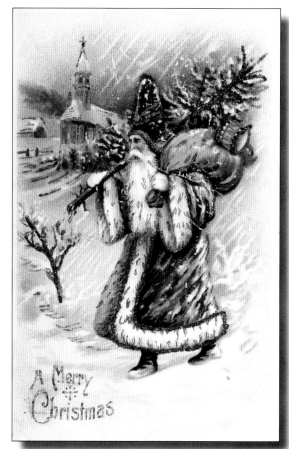

A Merry Christmas

Undated; $6-7.

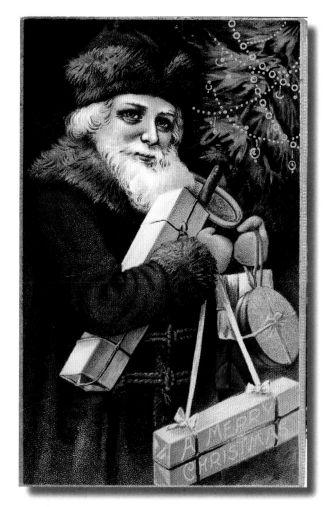

A MERRY CHRISTMAS

Undated; $30-40.

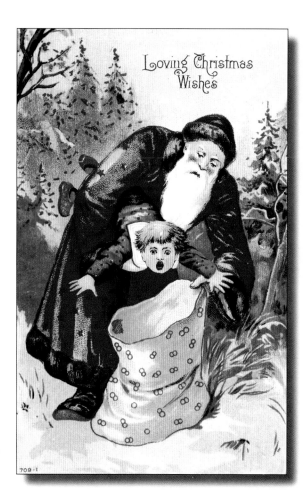

Loving Christmas Wishes

Undated; $12-14.

13

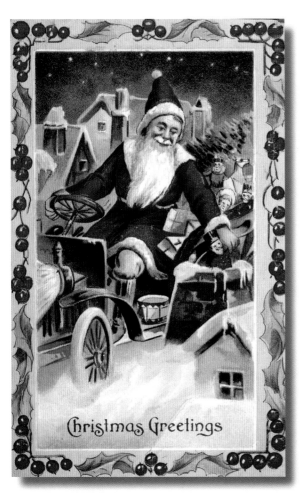

Christmas Greetings

Undated; $8-10.

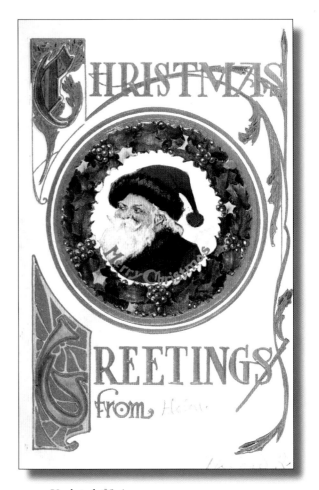

Undated; $3-4.

Seasons Greetings

Posted 1917; $3-4.

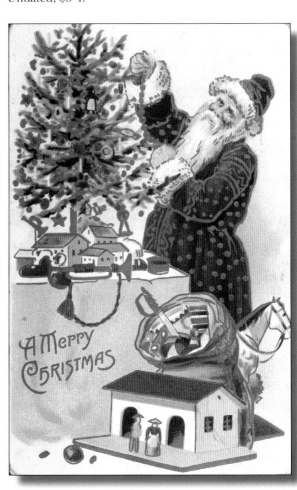

Undated; $6-8.

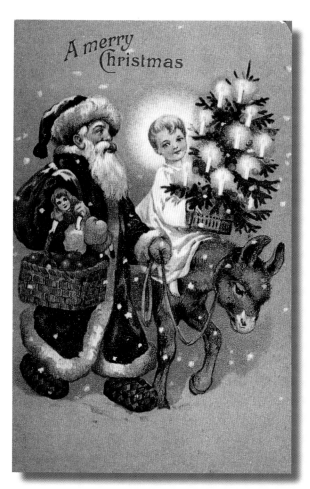

Undated; $6-8.

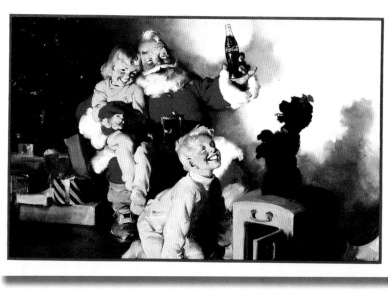

Coke postcard by Haddon Sundblom
Copyright 1991; $2-3.

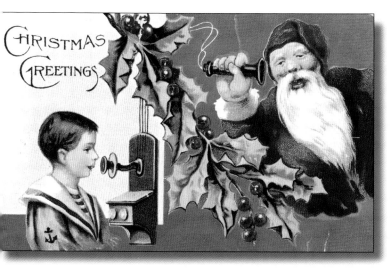

Undated; $6-8.

Undated; $5-6.

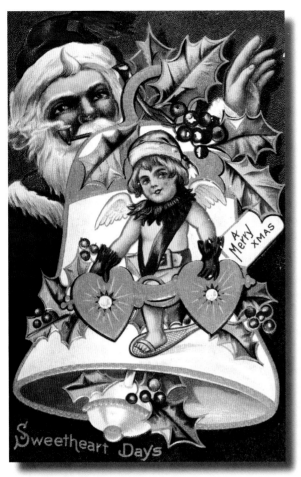

Undated; $6-8.

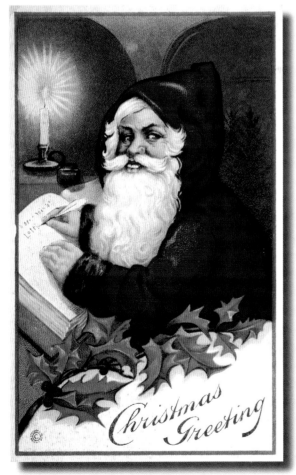

Undated; $8-10.

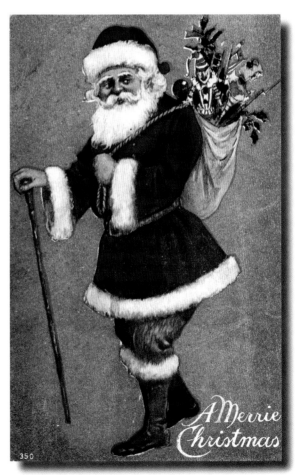

Undated; $8-10.

Undated; $5-6.

16

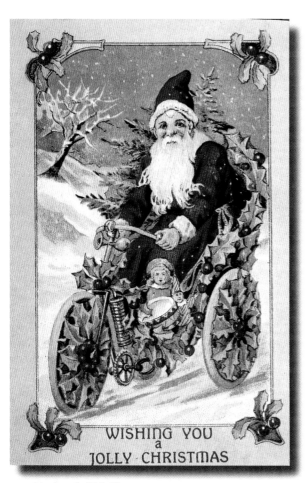

WISHING YOU
a
JOLLY CHRISTMAS

Undated; $12-15.

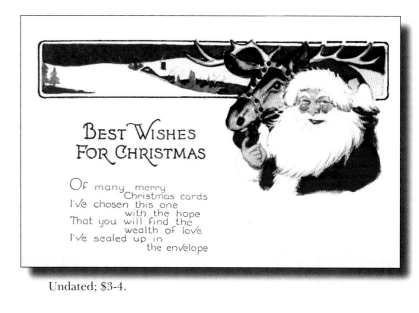

BEST WISHES
FOR CHRISTMAS

Of many merry
Christmas cards
I've chosen this one
with the hope
That you will find the
wealth of love
I've sealed up in
the envelope

Undated; $3-4.

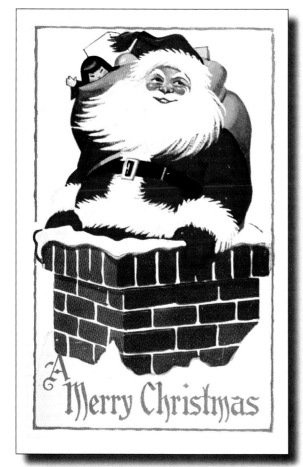

A Merry Christmas

Undated; $5-6.

With
Christmas
Wishes
kind and true,
That all
life's blessings
come to you

Undated; $6-7.

Other Yule Topics

Thousands of cards are annually exhibited to throngs of eager purchasers. The styles in decoration and form change yearly, but the sentiment—good will and good wishes—is ever the same.

<div align="right">

The Christmas Book
– Jane Stewart, 1908

</div>

Even in the beginning there were lots of different Christmas postcards to meet varying personal tastes. Consequently the postcards that remain from those days are equally varied. They range from the staid bright red and leafy Poinsettia to a sleigh and reindeer bounding across a blue and starry sky.

Judging from Stewart's comments and other published accounts, the public expected and received a wide assortment of holiday postcards to choose from. Moreover, people tended to purchase them in large numbers early in the twentieth century. Bargain hunters could sometimes find them as inexpensive as six different cards for five cents.

And despite popular misconception, Santa did not appear on every other early Christmas postcard. As welcomed as he may have been as a Christmas Eve visitor, the postcard marketplace was much broader. About ninety percent of the Yuletide postcard selections were in fact something other than the jolly fellow.

Enter then other Christmas postcard topics for collectors.

Christmas angels, decorated Christmas trees, fireplace scenes, and children at play or happily awaiting the arrival of you know who—might make an impressive collecting list.

Religious themes might make another. Oddly for a Christian holiday, the great majority of early Christmas postcards were of the secular type, offering more of a general focus on holiday decorations and such. However those Christmas postcards with religious themes were often striking and impressive. Madonna and Child, the Nativity, and Christmas angels are understandably special postcard choices of collectors today. Some collectors might opt for church scenes on Christmas postcards along with church-related views.

Birds alone, especially robins, dominated many early Christmas postcards. Early accounts dealing the Christmas postcards have noted that publishers at the time particularly favored robins amid holly branches. Perhaps the presence of the robin hinted at the promise of spring.

Dogs and cats on Christmas postcards were an oblivious favorite then and remain so today. Forever there have been legions of collectors attracted to most any image that lovingly depicts a Spot or a Tabby, which in turn resembles their own pet. Moreover, postcards of this nature seem to make wonderful gifts for the dog lover or cat lover in the circle of family and friends.

Speaking of animals, horses and donkeys also appeared on some Christmas postcards. Such depictions, however, were far less frequent than even dogs or cats, and therefore remain relatively scarce.

America was on the move early in the twentieth century and the Christmas postcards reflected this mood. Certain cards with a mechanized theme featured motorized vehicles including trucks, automobiles, and motorbikes. Some such cards took on a military presence as the events of World War I neared.

Snow scenes in general and outside winter activities in particular kindled interest among Christmas postcard buyers a century ago. Still warming the heart today are scenes of sledding and ice-skating of holidays past.

The telephone was a powerful image, sometimes effectively used in early Christmas postcards. Thousands of telephones were in use during that era, but they were still a marvel and a luxury. Less than one household in ten had such a device in 1908. They could be expensive too. For those with telephones at the time, a long-distance telephone call from coast to coast would cost then about $11—considerably more than the weekly salary of the average worker. Thus the telephone itself, and the telephone on Christmas postcards, was momentous.

Christmas postcards also managed to "prosper" during two art periods, Art Nouveau and Art Deco. Art Nouveau, with its flowing and organic forms, was popular from the 1890s well into the early 1900s. Meanwhile, Art Deco, with its contrasting clean and sharp lines, fully arrived in the 1920s. Both art styles were sometimes reflected in the postcards of their times—to the delight of contemporary collectors.

Some present day collectors go beyond the images of Christmas postcards themselves and dwell upon the hand-written messages on the back. This is a relatively new approach that is growing. Collectors are beginning to realize that these personally hand-written messages are in fact miniature historical documents of Christmas as it was actually lived a century ago. Their customs, anticipated gifts, hardships, occupations, and

relationships were all very meaningful and sometimes eloquently stated. Often the thoughts written carefully on the back of a Christmas card were the only time in the entire year such expressions were recorded.

Certain collectors today with a passion for folk art are now acquiring all the so-called homemade Christmas postcards. In far fewer numbers than commercial postcards, they contain unique hand-colored decorations along with a hand-printed word or two of original yuletide cheer.

For the collector today, like the distant relative who did the shopping, the Christmas postcard options are exciting and extensive.

Posted 1931; $3-4.

Undated; $6-8.

Wells Fargo Express
Undated; $4-5.

Undated; $3-4.

19

Undated; $2-3.

Undated; $3-4.

Undated; $4-5.

Undated; $5-7.

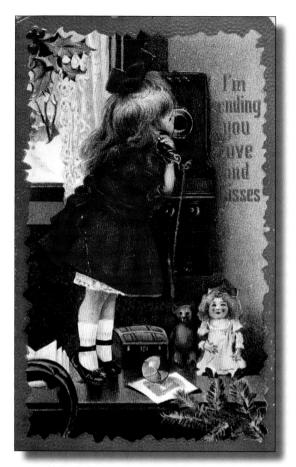

I like to
think that, like
a coach
Its Christmas
bounties bearing,
My wishes for your
happiness
Will many joys be sharing

2422A

Undated; $4-5.

Undated; $4-5.

CHRISTMAS·GREETING

I send A Merry Christmas
And my love to YOU . . .
My playmate says,"bow-wow"
Which really means"Me,too"

Undated; $2-4.

A Merry Christmas

Undated; $4-5.

Posted 1909; $1-3.

Undated; $3-4.

Posted 1923; $3-5.

Undated; $1-3.

John Winsch
Copyright 1911; $3-4.

Copyright 1908; $1-3.

Undated; $5-6.

Undated; $2-3.

Undated; $2-3.

Undated; $1-2.

Undated; $3-5.

Ellen Clapsaddle
Undated; $8-10.

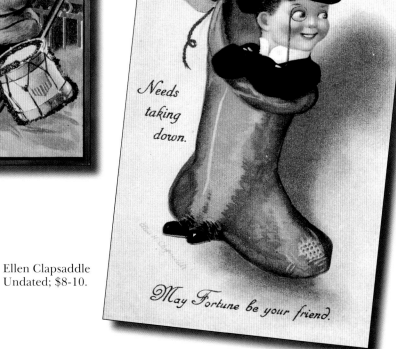

Undated; $4-5.

Undated; $1-3.

Undated; $4-5.

Undated; $3-5.

Undated; $2-3.

A. Frayel
Undated; $1-3.

MAY EVERY GOOD FORTUNE BE YOURS TODAY
AND MEMORIES OF CHRISTMAS ABIDE FOR AYE.

Undated $1-3.

Undated; $2-3.

Posted 1913; $1-3.

Undated; $2-3.

Undated; $1-3.

Undated; $1-2.

Key Artists, Publishers

In the world of early twentieth century Christmas postcards, there were noted artists and publishers. Some of them have transcended the years and draw attention yet today.

As a rule, the color, character, condition, and uniqueness of a vintage postcard is a determining factor for collectors. Adorable is adoptable.

Some collectors, however, base their collections almost entirely on the artist or publisher of a century ago and are usually willing a pay a premium if a particular name appears in script below the artwork or in small type elsewhere. Or in some cases the name might have been important enough to appear both ways.

In regard to postcard artists, the better of them were permitted or even encouraged to add their signature below their rendering. Some simply used initials, but most used the full names.

Bear in mind the use of an artist's name or initials was a sort of achieved status as their previous work had found its way into more and more earlier postcards. True scholars of some postcard artists can readily spot the budding work of an as yet unsigned artist. The quality of Ellen Clapsaddle's work, for example, was so unique that many advanced collectors can identify her early postcard works even before she achieved the status required for signing them.

Looking back, Ellen Clapsaddle may well have been the quintessential artist of America's Christmas postcards. Her vast number of renderings gave the public a world of adoring and adorable children surrounded lovingly by all things Christmas.

The woman was simply one of the most prolific postcard and greeting card artists of the entire era. Ellen Hattie Clapsaddle's work appeared virtually thousands of times. Her work with various holiday postcards was always distinguished. Her Christmas postcards were particularly compelling. Oddly, for all the cheerfulness and charm of her images, the life of the artist was less charming.

Ellen was born in January of 1865 in the small town of Columbia, New York. As a child she loved to express herself through her creative efforts. She once wrote in a poem to her mother, "My heart is a child." And that feeling was eternally reflected in her work.

As a young woman she completed courses at nearby Richfield Springs Seminary in 1882. Next Ellen studied art at New York City's Cooper Institute for nearly two years before returning home and offering painting lessons to local folks.

After her father's death in 1891, Ellen and her mother found it necessary to move to the familiar Richfield Springs and live with Ellen's aunt. For more than a decade Clapsaddle provided art lessons to local citizens and submitted an occasional portrait or landscape to the highly regarded International Art Company.

Ultimately the prolific Ellen Clapsaddle would produce between 2,000 and 3,000 postcard and related designs. Most were for International Art Company, which, in turn, was one of the most prolific of the postcard publishers. Most of her early offerings were unsigned, as was customary. Later on her signature was prominently featured below each rendering. A great many of Ellen's postcards, but certainly not all of them, centered on both children and holidays.

Eventually Art International was pleased enough and impressed enough with Ellen's work to send her on a prolonged trip to Germany. Among other things it seemed like a good idea to get the talented artist closely involved with the artistry and technology of German postcard production.

A refreshed and referenced Ellen returned to the United States around 1906, just as the flower of postcard popularity was in blossom. International Art at this point incorporated Ellen's contributions with their subsidiary operation, The Wolf Company. For the talented artist it was mixed blessing. Certainly there was an outlet for her robust work. She was in fact the only artist on the Wolf Company's staff. Ellen prospered, but her efforts were exhausting. The "lone" Wolf Company likewise prospered.

At age forty, Ellen Clapsaddle was a full-time artist and then some. She was enjoying the proverbial one-man band success at a time when very few women could boast of anything resembling a career in the arts.

Again another trip to Germany was scheduled. Both Ellen and the Wolf Company had heavily invested in unfailing German postcard production. The future seemed bright for both artist and publisher. It turned out to be just the opposite.

Tragically, Ellen arrived on this trip to Germany in 1914, at about the same time World War I erupted into flames. Ultimately German buildings and records were destroyed in the war's aftermath. Sources both at Wolf and in the Clapsaddle family lost contact with Ellen as the war's devastation continued.

At the end of World War I, a representative of the now slumping Wolf firm borrowed money to travel to Germany and search for the missing Ellen. She was

found, by most accounts, wandering the streets in a daze. Reportedly she barely realized her friend and co-worker from America. Ellen was in her fifties.

Whatever the causes, the artist never recovered. Ellen was returned to New York but she was no longer able to care for herself. Her state of heath continued to steadily but inexorably decline. The artist was admitted to the Peabody Home in 1932, apparently totally lacking any intellectual capacity. Less than twenty-four months later she was dead.

In the end, Ellen Hattie Clapsaddle, despite all her accomplishments, died alone. She had no family, no friends, and none of the revenues from her legendary talents.

Many years later, after still another world war, the woman's remains were finally relocated to the cemetery in Richfield Springs where her parents were buried. A marker at the feet of this remarkable Christmas postcard artist reads, simply, Ellen.

There were many other artists whose exceptional talents were captured from time to time on the canvas of the Christmas postcard. Frances Brundage was one of the most famous artists of her time to contribute to Christmas postcards. Ultimately her work appeared on calendars, trade cards, baby books, and various prints as well as postcards. She was most prolific during the first two decades of the twentieth century.

Grace Drayton, best know perhaps for her Campbell Soup Kids, used some of her talents on Christmas postcards. She also signed under the name Grace Wiederseim. Drayton's sister, Margaret Gebbie Hays, also did an occasional postcard rendering.

Rose O' Neill, famed for her Kewpie doll images of the 1900s, also did some Christmas postcards. Others included Clare Victor Dwiggins (DWIG), Margaret Evans Price (M.E.P.), Ethel DeWees (E.H.D.), and Bernhard Wall (WALL).

Additional artists well-established enough for a signature included H.B. Griggs (H.B.G.), Charles Twelvetrees, Kathryn Elliott, and F.G. Lewin. Even the famous commercial artist Harrison Fisher was signed on as the creator of the Miss Santa Claus postcard.

Less prolific but still profound were the postcard works of Richard Fenton Outcault, Franz Huld, Bertha Blodgett, Ruth Welch Silver, Samuel Schumucker, Cyrus Duran Chapman, Gertrude Pew, and Mary Russell.

As a group, artists of that period tended to work for the same postcard publisher. However most such artists were free-lance contributors rather than employees. As such, they could submit work to other publishers. Therefore, even the most accomplished artists may appear on the postcards of more than one publisher.

By the same token, most of the leading postcard publishers of the early twentieth century saw the profitability in publishing Christmas postcards. International Art Publishing was a leader in the field of Christmas postcards, and may have been second only at one time to England's vast Raphael Tuck and Sons' postcard publishing empire. Others included Gibson Art Company, the Illustrated Postcard Company, Leubrie & Elkus, Stecher Lithograph Company, John Winsch, and Whitney, to name but a few.

In addition to the more established postcard publishers of those decades, there were countless others who were doubtless smaller but able to produce at least a few Christmas postcards. Sometimes the full name of the publisher was used; at other times only the initials were presented.

Ellen Clapsaddle
Circa early 1900s; $20-25.

Ellen Clapsaddle
Circa early 1900s; $18-20.

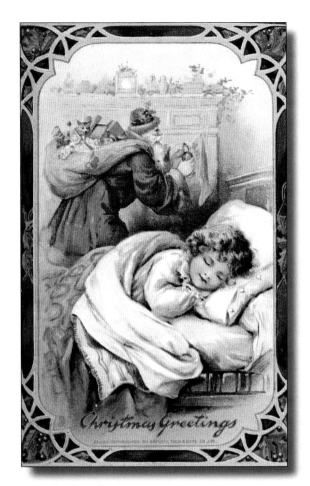

Tuck and Sons
Copyright 1908; $5-10.

John Winsch
Copyright 1913; $5-7.

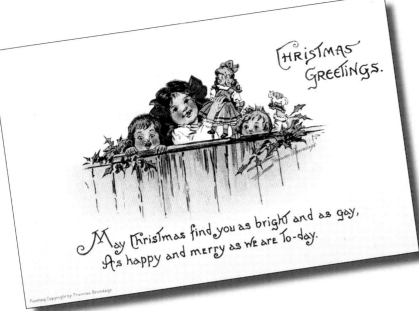

Frances Brundage
Undated; $10-15.

H.B. Griggs
Posted 1912; $5-6.

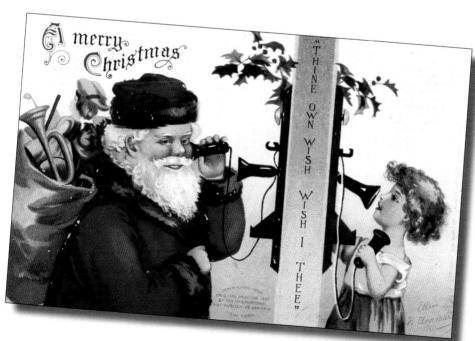

Ellen Clapsaddle
Copyright 1907; $8-10.

New Values in Old Cards

First it would be helpful to determine just what is old in terms of Christmas postcards. Old need not be entirely a relative term. The more or less "golden" years of the Christmas postcard and most other holiday postcards occurred during the first few decades of the twentieth century. They declined in popularity and somewhat in quality after that but continued to be published during the lean years of the 1930s and into the early 1940s.

As to determining the specific dates of such Christmas postcards, there are a few fairly obvious ways:

1. The postmark: Usually the date the card was mailed was hand-stamped on the back. For a time the card was stamped not only when it was mailed but also when it arrived at the receiving post office. Sometimes postmarks may be a little blurred, but usually they are readable enough to eek out a date.

2. Copyright date: Some publishers printed a small copyright date on the front or back of the postcard. Usually the name of the publisher was included with the copyright date. Bear in mind, however, that the majority of such publishers did not bother with providing a date.

3. A date provided by the sender: This might be simply Merry Christmas 1908, or just the date 1910. Technically the greetings could have been sent years after the postcard was actually printed, but generally such handwritten dating is helpful.

4. Careful comparison: In the case of a Christmas postcard with no markings, it may be compared side-by-side with postmarked cards. It is hardly an exact method but can provide some clues toward at least an era.

5. Christmas Seals: The idea of using adhesive stickers for the Christmas season originated in Denmark early in the twentieth century. By 1907, due to the efforts of Red Cross worker Emily Bissell, it was used on a limited regional basis in the United States. In 1908 the American Red Cross launched a national Christmas Seal campaign. The decorative seals were then issued each year for many years. Starting in 1920, the Red Cross relinquished sponsorship to the National Tuberculosis Association, but every annual issue was still dated.

The 1908 Christmas Seal is still considered the rarest of the issues. Its design included an open wreath with "National American Red Cross" in red. In 1909 (pictured here), the image bore the date and American Red Cross in green. In the center was a bright red cross symbolic of the organization. By 1918, the Statue of Liberty was added and in 1920 the Christmas Seal featured Santa and a child.

Now, as to actually locating vintage Christmas postcards, there are many ways.

Try Households

There was a time when nearly every household in America held at least a small number of Christmas postcards. They were popular, they were attractive, they were inexpensive, and they provided wonderful means to express Yuletide greetings to friends and family.

Then too, they were personal. That postcard with the smiling little girl bedecked in a starchy white apron may also bear the last handwritten message ever from Grandma. Or the red-suited Santa may be the postcard mailed by Uncle Morley when he was away working in the oil fields.

As the second generation came around the Christmas postcards were older, but they still were personal. Many still had that family connection. Most of the senders and receivers may be deceased, but still other family members remembered them. Gradually the little stack of Christmas postcards became a family heirloom.

Even today, a century later, it is not so unusual to encounter someone who has managed through all the years and all the generations to have stored away family-related Christmas postcards. Then, just as surely, a succeeding relative will at last conclude the connections are too obscure. So out they go to someone expressing an interest, or out to someone offering a monetary reward.

As this book was being written, a friend telephoned with news of a household postcard discovery. In closing a deceased relative's estate, the friend asked the realtor to review the premises. Up among the rafters of an adjoining back porch was a scrapbook of old postcards including many Christmas greetings.

So, as a little girl named Dorothy once said, "There's no place like home."

Try Shops and Malls

Good news here, most every antique shop and antique mall in America has at least one selection of postcards. Usually that particular selection includes Christmas greetings.

It also helps here to ask. Antique shop owners and

operators are usually quite helpful in addressing your customer interest. Perhaps they can alert their crew of dealers to your interest. Maybe they can notify you when a new lot of old postcards arrives at their shop. It happens. Leave a "want" card with your name and e-mail address or telephone number.

Try the Internet

To some Americans, the Internet is as second nature as driving an automobile. For those less familiar, almost any teenager in the neighborhood should be able to provide the necessary technical advice.

E-bay is of course the biggest marketplace of all on the Internet. It is one giant moving train filled with passengers both buying and selling. Each day is different. The train-like market is thus always moving; some passengers depart while others climb aboard.

When it comes to Christmas postcards, and a vast number of other things, E-bay is a wonderful way to window shop. In a relatively short time, the attentive viewer can see and read about all sorts of individual Christmas postcards and groups (or lots) of Christmas postcards.

One clear advantage to the Internet in general and E-bay in particular is the access to a wide section of items in a fairly short span of time. The disadvantage is the viewer is unable to actually pick up the Christmas postcard and examine it. Much depends on the seller. The postcard may actually be even nicer that it appears on the image (scan). Or it could be less nice.

As a general rule, the Internet buyer can expect a somewhat better rate per postcard when purchasing a group or postcard lot than a buyer simply purchasing an individual postcard. A purchase of a 100 Christmas postcards mix, with everything from Poinsettias to Santa, for example, might average out to only a few dollars each. However, making an individual purchase, perhaps adhering to one particular theme or single topic, might raise the card price average considerably.

Also be aware of shipping, handling, and postage costs. Once we purchased a fairly impressive Christmas postcard via the Internet for only one dollar. However, the dealer charged nearly another $5 for delivery. In the end, this particular Christmas postcard was really well worth the entire $6 it cost. Still, the lesson was well learned.

Auctions as Well

An estate auction can be a grand adventure. Typically such auctions involve an entire household and all of its likely or even unlikely contents. It can be a fascinating experience, but plan to spend lots of time. Sometimes larger estate auctions involved two or more auctioneers operating at virtually the same time in different parts of the same sale location. Plan ahead for a long stay and read any advertisements and handbills carefully for any mention of postcards or Christmas items.

Specialized Sites

Around the country there specific postcard shows that attract established and experienced dealers who specialize in postcards. Typically such dealers have spent years buying and selling postcards as their livelihood.

Likewise, there are notable mail-order auctions which specialize in all types of postcards, both as singles and in lots. Consult antique and collectible publications for current information on both sites. For even more information, consider specialty publications such as *Postcard Collector* and *Barr's Postcard News*.

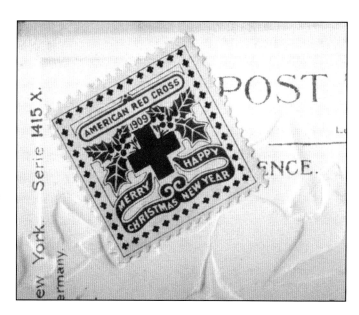

Christmas Seal 1909 American Red Cross

Early Christmas postcard sticker but not Red Cross

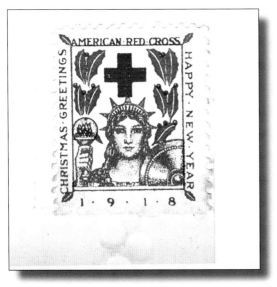

Christmas Seal 1918
American Red Cross

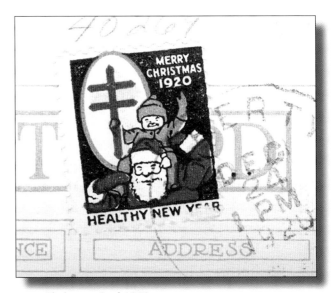

Christmas Seal 1920
Santa and child

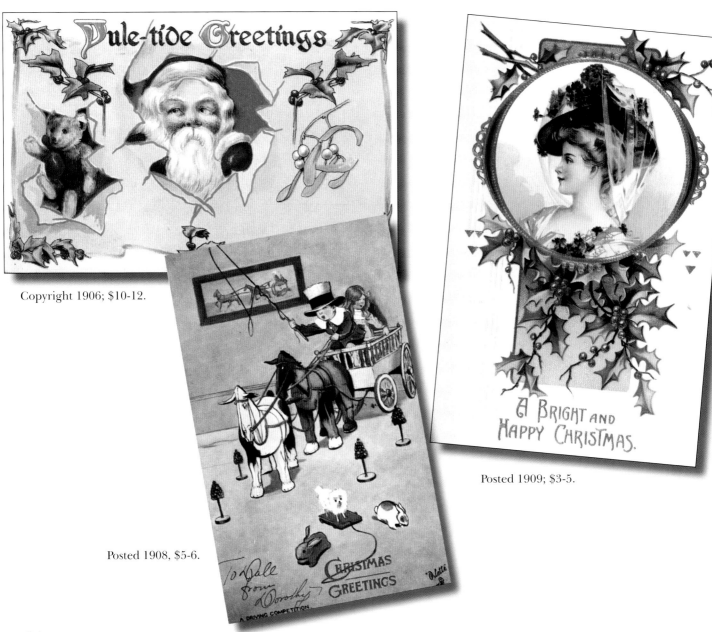

Copyright 1906; $10-12.

Posted 1908, $5-6.

Posted 1909; $3-5.

Circa 1900s, $6-8.

Copyright 1910, $2-4.

Undated, $5-6.

Written date 1911, $2-3.

Circa 1900s, $4-5.

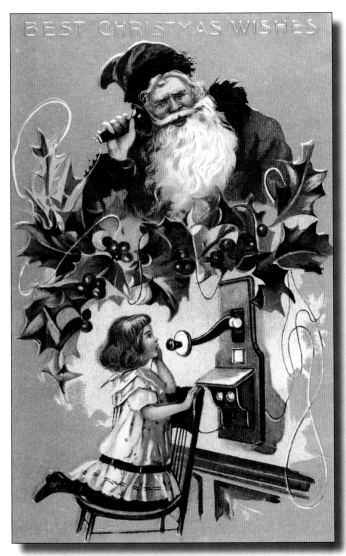

Written date 1910; $5-7.

Undated, $5-6.

Undated; $3-4.

Circa 1900s; $3-4.

Undated; $4-5.

Decade 1900 - 1909

America met the first decade of the twentieth century with a good degree of optimism and a large measure of "taking care of business." Life was simple and work was available. Early in the 1900s, the country produced more than half of the world's cotton, corn, copper, and oil. It also accounted for more than a third of the entire planet's steel, iron, and silver.

Baseball, chewing gum, boiled dinners, rocking chairs, pie, and ice-water were popular new terms. At the marketplace, eggs were fourteen cents a dozen, butter was twenty-four cents a pound, and a bushel of nice potatoes was running between thirty-five and forty-five cents.

In Maryland, a boarding house advertised supper and breakfast at fifteen cents per meal. A turkey dinner, however, was twenty cents. In New Jersey, one major hotel offered rates of $1 per day, but furnished rooms were as low as fifty cents daily.

A good, well-made corset in long or short style sold for fifty cents in an Illinois store. Lady cashiers were being hired at $8 per week in Los Angeles, and in New York the rate for male stenographers was $10 per week. Meanwhile, in St. Louis, a firm advertised for a night watchman with "absolute proof of honesty and sobriety." For six nights a week with Saturday nights off, the pay was $15 per week.

In fashion news, the experts recommended new lightweight skirts so ladies could gather them up in their hands to keep clear of muddy pavements.

Citizens in Wichita, Kansas, feuded early in that era over the proposed Arkansas River bridge. Some wanted it wide enough for streetcars. Others argued just as strongly that the streetcars would frighten the horses.

Old soldiers of the Civil War, organized as the Grand Army of the Republic, were very active and very influential around the country. Women, however, did not fare as well. Early in the 1900s only four states—Idaho, Wyoming, Utah, and Colorado—allowed women to vote. The reform movement of women's suffrage would struggle through the next decade as well.

Ox-teams were a common sight on country roads in those days, and horse-drawn streetcars frequented the cities. The blacksmith was still in business in most towns, and croquet was the outdoor game of choice.

Generally the roadways of America were pretty primitive in the 1900 to 1909 era. The outer edges of most cities at the time "were a kind of frontier," wrote Mark Sullivan in the book, *Our Times: United States 1900-1925*. "Unfinished streets were pushing out to the fields; sidewalks where there were any, either of brick that loosened with the first thaw, or wood that rotten quickly; rapid growth leading to rapid change."

Still, the need for roads was not great. Depending on whose figures you select, there were only 5,000 to 8,000 automobiles operating in the United States early in the twentieth century. They were a novelty on the streets as well as on postcards. As the decade began, there were fewer than ten miles of concrete roads in all of America.

On the streets of New York, as holiday postcards began their rise to popularity, a majority of the automobiles that existed were electric cars. The next most numerous were steam-operated cars. Only a fraction of the available automobiles were gasoline powered.

Still even the few were proving hazardous to the many. Wagons and people were being run over by automobiles. In 1904 the state of New York passed a speed limit law. It allowed for ten miles an hour in built-up city districts, fifteen miles an hour on the outskirts of cities and towns, and twenty miles an hour every place else. Other states soon followed.

Meanwhile, the parade of colorful Christmas postcards, like the automobile, was steadily moving forward.

Copyright 1906; $4-5.

Written date 1906; $1-2.

Undated; $1-2.

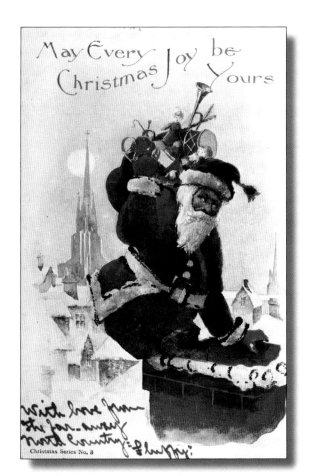

Posted 1906; $5-6.

Undated; $1-2.

BEST
Christmas Wishes

Posted 1906; $3-4.

"Brave hope for days to be.
The granting of one's best desires
I ask it all for thee."

Posted 1906; $1-2.

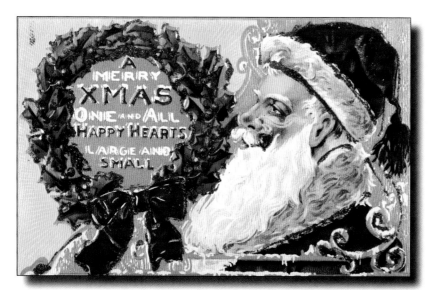

A MERRY XMAS ONE AND ALL HAPPY HEARTS LARGE AND SMALL

Circa 1900s; $4-5.

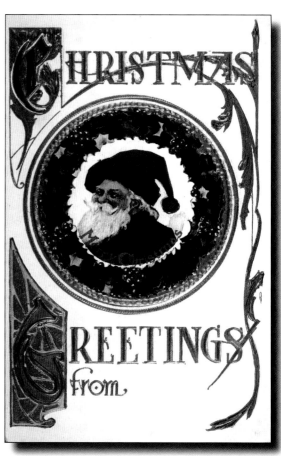

CHRISTMAS GREETINGS from

Undated; $3-4.

Posted 1906; $2-3.

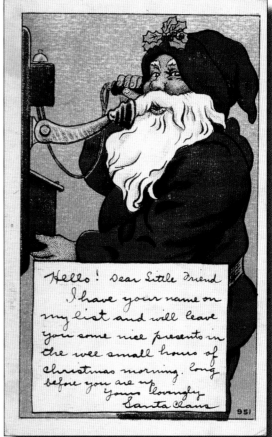

Posted 1906; $5-7.

Posted 1907; $1-2.

Handmade card
Posted 1907; $3-4.

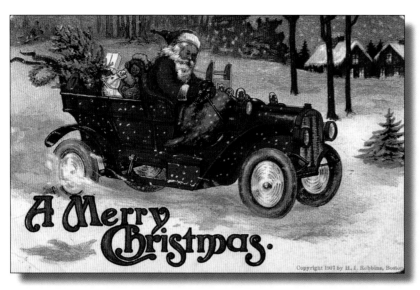

Copyright 1907; $20-30.

Undated; $3-4.

Written date 1907; $2-3.

Posted 1907; $1-2.

"To wish you a stocking
 with presents stuffed high,
And plenty of plums in your Christmas pie."

Copyright 1907; $1-2.

Undated; $2-3.

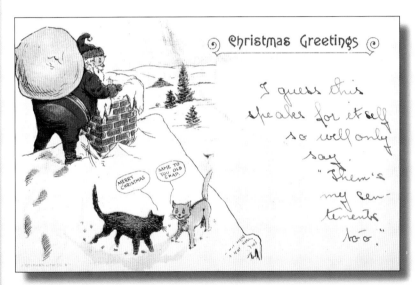

Posted 1907; $4-5.

Tuck Yuletide series
Posted 1907; $1-2.

Undated, $1-2.

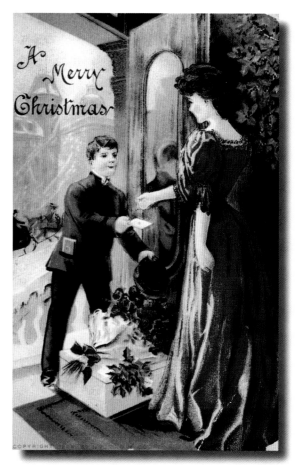

Posted 1907; $4-5.

Circa 1900; $1-2.

Posted 1907, $2-3.

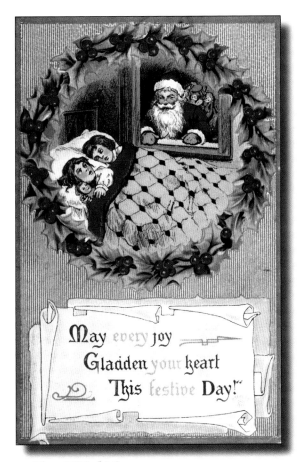

May every joy
Gladden your heart
This festive Day!"

Circa 1900; $5-6.

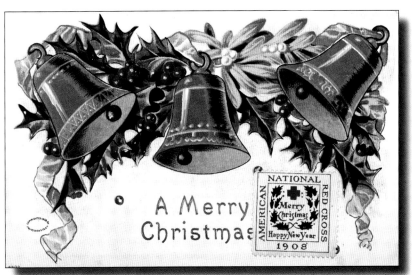

With rare 1908 Christmas Seal
Dated 1908; $8-10.

Christmas
Greetings

Posted 1908; $2-3.

Circa 1900; $1-2.

Merry Christmas,
 Little Boy:—
If you have been
real good, I will stop
at your house first
and leave lots of nice
presents. Hang up
your stocking
 Your loving friend
 Santa Claus.

954

Written date 1908; $4-5.

With Best
Christmas Wishes

Posted 1908; $1-2.

A
Merry
Christmas

Posted 1908; $1-2.

Christmas with its magic
spell, Make all things
happy, all things well.

1908.

Written date 1908; $1-2.

Copyright 1908; $9-12.

Posted 1908; $1-2.

Posted 1908; $1-2.

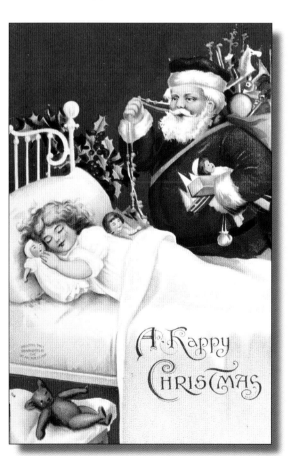

Unsigned Ellen Clapsaddle
Posted 1908; $20-24.

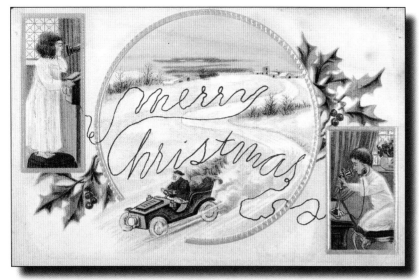

Undated; $5-6.

Hand-written message
"Hello Jule, Have to get up to a big Xmas
dinner, wish you could be here too. Hillie."
Posted 1908; $1-2.

Posted 1908; $1-2.

Copyright 1908; $1-2.

Posted 1908; $1-2.

Copyright 1908; $3-5.

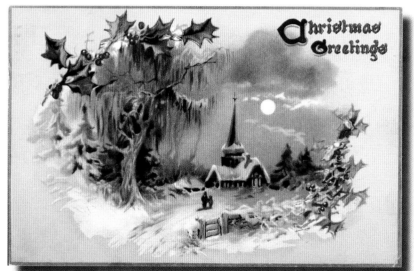

Tuck & Sons
Posted 1908; $2-3.

Posted 1908; $1-2.

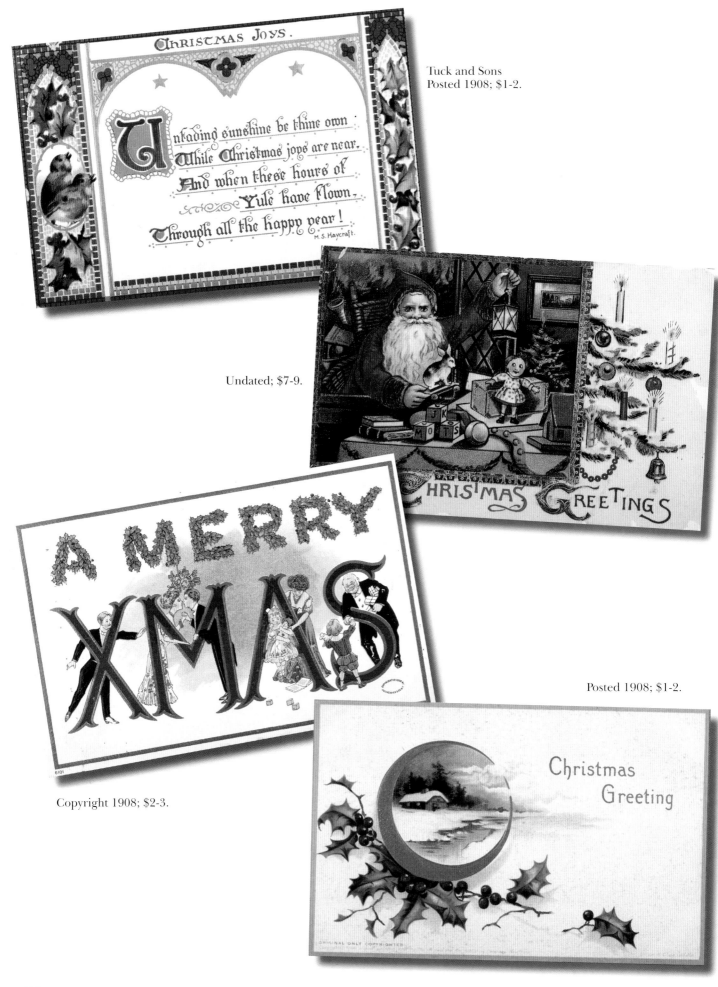

CHRISTMAS JOYS.

Unfading sunshine be thine own
While Christmas joys are near,
And when these hours of
Yule have flown,
Through all the happy year!

M.S. Haycraft.

Tuck and Sons
Posted 1908; $1-2.

Undated; $7-9.

CHRISTMAS GREETINGS

A MERRY XMAS

Copyright 1908; $2-3.

Posted 1908; $1-2.

Christmas Greeting

Written date 1908; $3-4.

Posted 1908; $1-2.

Posted 1908; $1-2.

Posted 1908; $1-2.

Posted 1908; $1-2.

A Joyful Christmas
to You

Posted 1908; $3-5.

Tuck and Sons
Posted 1908; $24-30.

Tuck and Sons
Posted 1908; $1-2.

Posted 1908; $1-2.

Undated; $1-2.

Copyright 1908; $6-8.

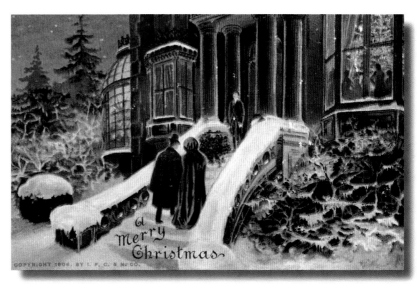

Posted 1908; $3-4.

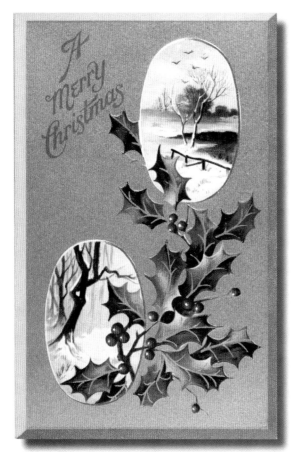

Hand-written message: "Well Grandma, hope you are well this Christmas. You have been spared to see a good many ones haven't you. It has been for some good purpose you know. Don't think we'll see as many as you, I doubt it. Everybody is well here. Gret." Posted 1908; $1-2.

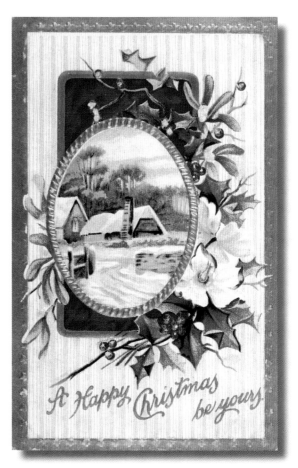

Posted 1908; $1-2.

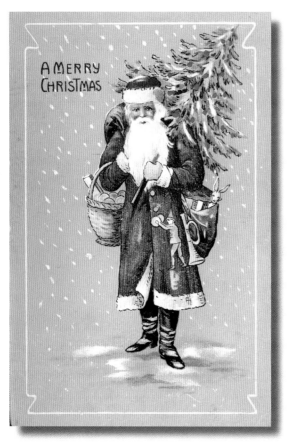

Posted 1908; $8-10.

Posted 1908; $1-2.

Posted 1908; $1-2.

Undated; $5-6.

Posted 1908; $1-2.

Posted 1908; $1-2.

Posted 1908; $1-2.

Posted 1908; $1-2.

Posted 1908; $1-2

Posted 1908; $1-2.

Copyright 1908; $3-4.

Posted 1909; $4-5.

Posted 1908; $1-2.

Posted 1908; $1-2.

Posted 1909; $1-2.

Posted 1909; $1-2.

1909 Christmas Seal
Dated 1909; $3-5.

Posted 1909; $3-4.

Posted 1909; $1-2.

Copyright 1909; $1-2.

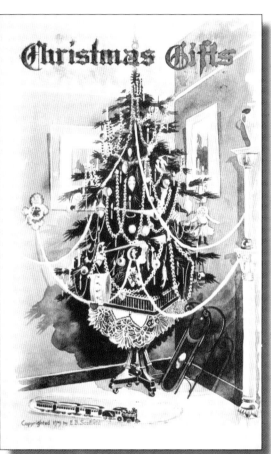

Copyright 1909; $3-5.

Posted 1909, $1-2.

Hand-written date 1909; $1-2.

Posted 1909; $1-2.

Posted 1909; $1-2.

Undated; $2-3.

A Merry Christmas.

Copyright 1909; $5-6.

Best Wishes for a Merry Christmas.

Posted 1909; $1-2.

A Merry Christmas

Posted 1909; $3-4.

Wishing You a Merry Christmas

Hand-written date 1909; $1-2.

Circa 1900s; $5-6.

Hand-written date 1909; $2-3.

Posted 1909; $3-4.

Hand-written date 1909; $2-3.

Posted 1909; $1-2.

Posted 1909; $2-3.

Posted 1909; $1-2.

Posted 1909; $1-2.

Posted 1909; $4-5.

Copyright 1909; $8-12.

Posted 1909; $3-4.

Posted 1909; $1-2.

Posted 1909; $1-2.

Posted 1909; $1-2.

Posted 1909; $1-2.

Posted 1909; $1-2.

Posted 1909; $4-6.

Posted 1909; $1-2.

1909 Christmas Seal
Posted 1909, $2-3.

Posted 1909; $1-2.

Posted 1909; $1-2.

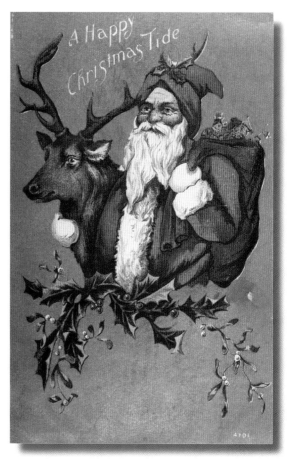

Posted 1909; $4-5.

Hand-written date 1909; $1-2.

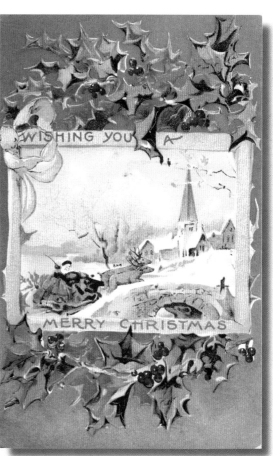

Posted 1909; $1-2.

A Merry Christmas

Posted 1909; $1-2.

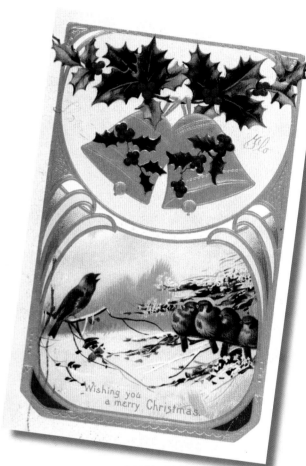

Wishing you a merry Christmas

Posted 1909; $1-2.

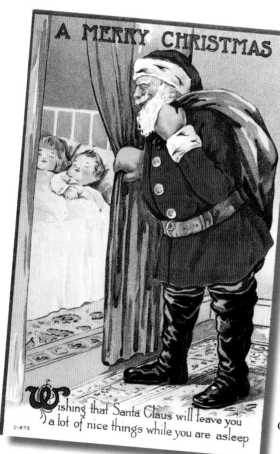

A MERRY CHRISTMAS

Wishing that Santa Claus will leave you a lot of nice things while you are asleep

C-273

Circa 1900s; $10-14.

Decade 1910 - 1919

By the second decade of the twentieth century America was on the move, figuratively and literally. The motorbus arrived on the scene around 1910. Sometimes known as the "jitney," it simply allowed more people to travel in a vehicle. Soon the jitney, or expanded pleasure car, would be replaced by the much larger bus.

Automobile production, meanwhile, was also on the rise. It had barely nudged the 187,000 mark in 1910, but it would roll on to a thundering two million by the end of 1919.

When not riding, some Americans were also attracted to dancing. In 1911 Irving Berlin's "Alexander's Ragtime Band" was introduced to mixed reactions. The following year saw W.C. Handy's "Memphis Blues" and the even more popular "St. Louis Blues."

Americans grew in other ways too. Nearly four and a half million immigrants literally came to America over a four-year period starting in 1911. Citizens, whether native or foreign-born, could read and write as well. The literacy rate in the U.S. actually rose from an impressive ninety-two percent in 1910 to an even better ninety-four percent of the adult population in 1919.

The Girl Scout organization was founded in 1912 by Juliette Low of Savannah, Georgia. Soon both boys and girls were participating in activities such as camping, swimming, and woodcraft. And the outdoors was not all that different from the indoors. That same year only sixteen percent of America's households had electric lighting.

Big seemed better somehow. In New York City, the Woolworth building was finally completed in 1912. Designed by "new school" architect Gilbert Chase, it soared fifty-seven stories into the sky. The term skyscraper, by the way, had originated during the 1880s when buildings reached a remarkable ten stories high.

Styles of clothing came to have an increasing impact on the general public. Once a particular style of women's dress flooded the local retail shops, older models were difficult to find. All the ladies wanted to look their best when strolling the avenues. In 1913, the fashion conscious *Harper's Weekly* published a tongue-in-cheek article entitled, "The Story of the Skimpy Skirt."

Elsewhere the railroad was anything but skimpy. By 1913 the United States was moving on more than 250,000 miles of railroad track. In fact it amounted to more than a third of the world's total.

Small seemed okay too. Some eighty-eight percent of all manufacturing in the United States of 1914 was done in factories or shops producing less than $100,000 in goods annually. In American factories that same year, the average workweek was fifty-five hours, for which the weekly wage was around $16. The trouble was with purchasing power, the $16 pay bought even less than that which $13 had bought in 1900.

There was less drinking also, at least in public. By 1914, statewide prohibition existed or was scheduled to soon exist in eleven states. Over the next few years the number of "non-drinking" prohibition states more than tripled. Ultimately such restrictions would become part of the U.S. Constitution before the decade ended.

And the world grew a little smaller, at least in terms of travel. In August of 1914 the Panama Canal was informally opened with the passage of the United States steamer *Ancon*.

There was little hum in the economy mid-way through that same ten-year period. Orders for goods from France and England increase as early as 1915 as Europe prepared for military conflict. Eventually America would also be swept into the worldwide conflict. The U.S. postal system meanwhile sprouted wings with the first airmail service from Washington to New York that same year.

Through it all a desire for the "liberty" of the automobile steadily grew. In 1916 Congress passed the Good Roads Bill, which provided an appropriation by the federal government of $85 million dollars. It was to be distributed among the states based on area, population, and something called post-road mileage. The states meanwhile were required to pay equal amounts for the construction of good roads.

By 1917, America was fully engaged in World War I. The soldiers called to war were ironically often the grandsons of Civil War veterans. One writer described a scene that year at a train depot in a small midwestern town. There the few surviving members of the Grand Army of the Republic gathered for a send-off of young draftees.

With the war came a new demand for increasing the nation's "sin" taxes. Heavy rates were imposed on numerous luxuries, amusements, tobacco, and beverages. Citizens also paid to finance the war effort through four different Liberty Loans and even twenty-five-cent war savings stamps. Despite all efforts, the American national debt rose to nearly $26 billion dollars by 1919.

As the war ended, women who earlier had few professions open beyond teaching or stenography now had more prominence in occupations. Women filled jobs

during the war that has previously been held only by their male counterparts.

Christmas postcards, refreshingly colorful and available at every shop and store, were at the height of their popularity.

Posted 1910; $1-2.

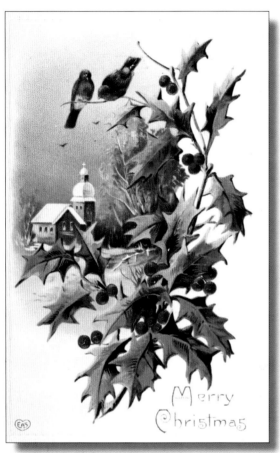

Hand-written date 1910; $1-2.

Ellen Clapsaddle
Posted 1910; $2-3.

Posted 1910; $10-12.

Posted 1910; $1-2.

Posted 1910; $2-3.

Posted 1910; $1-2.

Posted 1910; $1-2.

Undated; $4-5.

Undated; $1-2.

Posted 1910; $1-2.

Undated; $4-5.

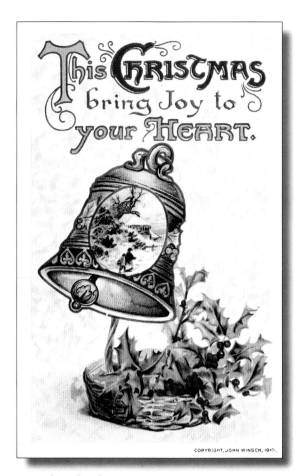

This CHRISTMAS
bring Joy to
your HEART.

COPYRIGHT, JOHN WINSCH, 1910.

John Winsch
Copyright 1910; $1-2.

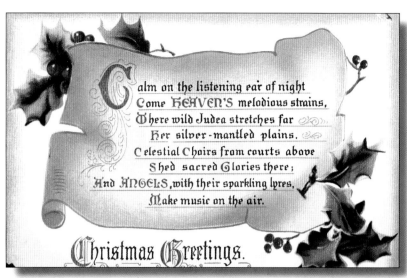

Calm on the listening ear of night
Come HEAVEN'S melodious strains,
Where wild Judea stretches far
Her silver-mantled plains.
Celestial Choirs from courts above
Shed sacred Glories there;
And ANGELS, with their sparkling lyres,
Make music on the air.

Christmas Greetings.

Posted 1910; $1-2.

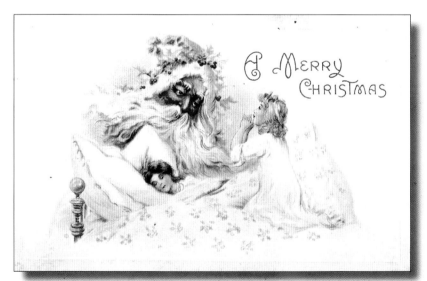

A MERRY CHRISTMAS

A.S. Meeker
Copyright 1910; $3-4.

CHRISTMAS GREETINGS

Posted 1910; $1-2.

Posted 1910; $1-2.

Undated; $6-8.

BEST WISHES for CHRISTMAS

A Hearty Christmas Greeting

Christmas Seal
Hand-written date 1910; $1-2.

The Season's Greetings

Posted 1910; $1-2.

74

Posted 1910; $1-2.

Message reads:
"Dear Grandma and Grandpa I would like
four you to come to our house a Christmas.
Good by, Katherine."
Posted 1910; $4-5.

Posted 1910; $1-2.

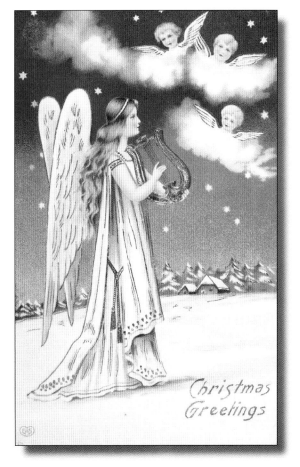

Hand-written date 1910; $3-4.

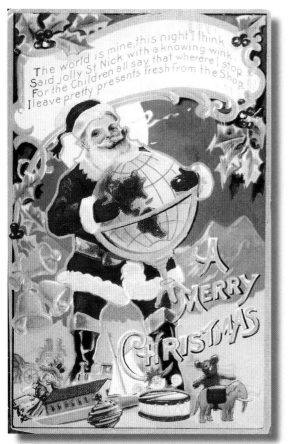

The world is mine, this night I think.
Said jolly St. Nick with a knowing wink.
For the Children all say that where I stop
I leave pretty presents fresh from the Shop.

A MERRY Christmas

Undated; $3-5.

Hand-written date 1910; $1-2.

A Merry Christmas

Posted 1910; $4-5.

A Merry Christmas

AMERICAN NATIONAL RED CROSS
Merry Christmas
Happy New Year
1908

Posted 1910; (see page 45) $8-10.

Posted 1910; $2-4.

A Merry Christmas

Posted 1910; $1-2.

A Christmas Wish.

May the Divine joy, which inspired the song of the Holy Angels when Jesus was born, fill your heart with peace and good will, and crown your days with light.

Posted 1910; $1-2.

My Christmas Offering

Posted 1910; $2-3.

H. Wessler
Copyright 1910; $15-20.

Hand-written date 1910; $1-2.

Posted 1910; $2-3.

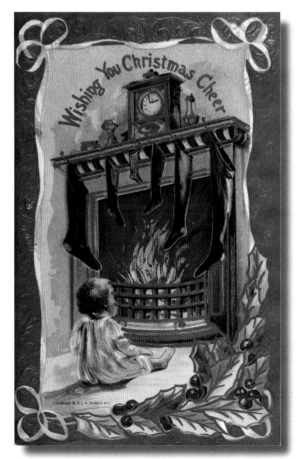

Copyright 1910; $4-5.

Posted 1910; $1-2.

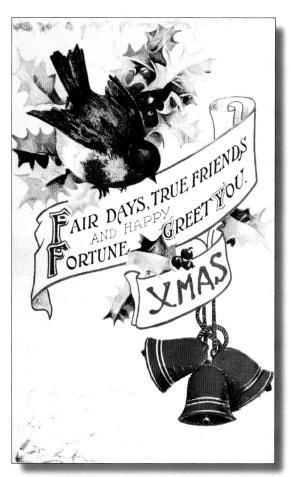

Undated; $1-2.

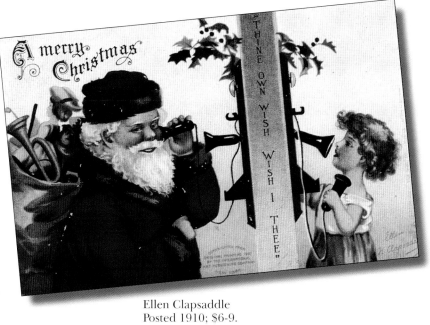

Ellen Clapsaddle
Posted 1910; $6-9.

Posted 1910; $1-2.

Hand-written date 1910; $4-5.

Posted 1910; $1-2.

Undated; $3-4.

Posted 1910; $1-2.

Hand-written date 1910; $1-2.

John Winsch
Copyright 1910; $1-2.

A.B. Meeker
Copyright 1910; $1-3.

Hand-written date 1910; $2-3.

81

A.S. Meeker
Copyright 1910; $1-2.

Posted 1910; $1-2.

Posted 1910; $4-5.

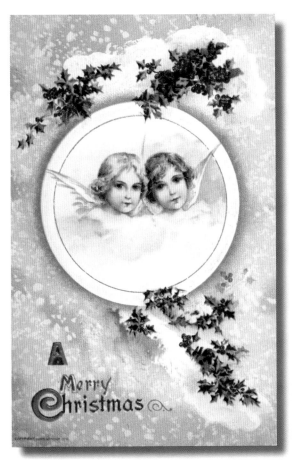

John Winsch
Copyright 1910; $1-2.

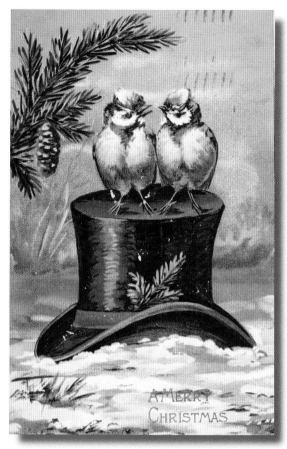

Message on reverse reads:
"Here is a nice plug hat for a Christmas gift. Hope
you like it. Mother has not been feeling good and
didn't sleep very much last night. Best wishes for a
Merry Christmas."
Posted 1910; $5-6.

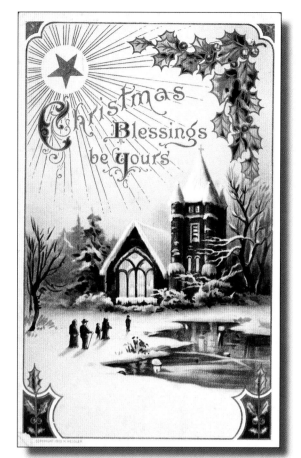

Wessler
Copyright 1910; $2-3.

Posted 1910; $1-2.

Posted 1910; $1-2.

Posted 1910; $2-3.

Posted 1910; $1-2.

Posted 1910; $1-2.

Posted 1910; $1-2.

Message on reverse:
"Dear Cousin, Was very much pleased to be remembered with the various post cards you have sent—altho I have not said so. This is to wish yourself and wife the happiest and best Christmas ever. Am always glade to hear from you. Pearl."
Posted 1910; $1-2.

Posted 1910; $1-2

Posted 1910; $1-2.

Posted 1910; $8-10.

Posted 1910; $1-2.

Message on reverse:
"Dear Roy and Bertha, I wish I could send all of you a nice present but it seems that money is so scarce at the holidays than at any other time. So I will send this card to let you know I haven't forgotten you. It is snowing at this time so it looks as enough we will have a white Christmas. With love, Aunt Clara."
Posted 1910; $1-2.

Undated; $2-3.

John Winsch
Copyright 1911; $5-6.

Message on reverse reads:
"Well Charlie you better come up Christmas. Oriss
is looking for you to go hunting with him in the four
noon. We can furnish footwear. A.H.B."
Hand-written date 1911; $1-2

Posted 1911; $3-4.

Hand-written date 1911; $1-2.

Posted 1911; $1-2.

Posted 1911; $1-2.

John Winsch
Copyright 1911; $6-8.

Posted 1911; $1-2.

Posted 1911; $1-2.

Undated; $1-2.

Posted 1911; $5-8

Posted 1911; $1-2.

Posted 1911; $1-2.

Hand-written date 1911; $1-2.

Posted 1911; $2-4.

Hand-written
date 1911; $1-2.

Hand-written date 1911; $1-2.

To·Greet·You

A Merry Merry Christmas,

And a Happy, Happy Year.

May every year that comes and goes,

Brighter prospects yet disclose.

Posted 1911;
$1-2.

Posted 1911; $1-2.

Posted 1911; $6-8.

Posted 1911; $1-2.

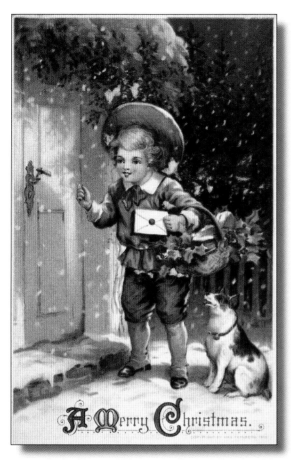

Max Feinberg
Copyright 1911; $3-5.

Posted 1911; $1-2.

Hand-written date 1911; $1-2.

Posted 1911; $2-3.

Hand-written date 1911; $1-2.

Posted 1911; $1-2.

Posted 1911; $2-3.

Posted 1911; $1-2.

Posted 1911; $2-3.

K

eep your face always towards the sunshine, and the shadows will fall behind you

With every good wish for a happy Christmas

From Bro & Sister

Posted 1911; $1-2.

Christmas Greetings

Posted 1911; $1-2.

Clear the Track for Merry Christmas

H.B. Griggs
Posted 1911; $5-6.

Hearty Xmas Wishes

Posted 1911; $1-2.

To wish you a Christmas, Merry and Glad, And the Happiest time you Ever have had.

XMAS

Joyous Greeting

Posted 1911; $1-2.

Copyright 1911; $1-2.

CHRISTMAS GREETING

MAY a ribbon of friendship
Forever extend
From your heart to mine;
Sincerely your friend.

Volland and Company
Copyright 1911; $1-2.

Posted 1911; $1-2.

A PEACEFUL CHRISTMAS TO YOU.

Message on reverse:
"Please accept this Christmas present."
Hand-written date 1911; $3-4.

Posted 1911; $1-2.

With best Christmas Wishes

Posted 1911; $1-2.

A Merry Christmas

Posted 1911; $1-2.

With Hearty Greetings

All Kind Thoughts and Best Wishes for a Happy Christmas

Posted 1911; $1-2.

A Merry Christmas

Posted 1911; $1-2.

Glad Tidings of Christmas

Posted 1911; $1-2.

A Happy Christmas

Posted 1911; $1-2.

Posted 1911; $1-2.

Posted 1911; $1-2.

Posted 1911; $1-2.

Message on reverse reads:
Dear Mina. Wish you a Merry Xmas. It will be a sad one for us. Ma is some better but has been very poorly. For a while we feared the worst, but maybe she will get better now. Oh, Alica remembers us. Will write soon. Ida."
Posted 1911; $2-3.

Posted 1911; $1-2.

Copyright 1912; $1-2.

Posted 1912; $1-2.

Posted 1912; $1-2.

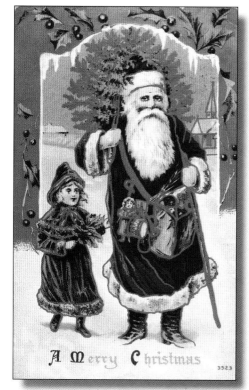

Posted 1912; $4-5.

Undated; $3-4.

Posted 1912; $1-2.

Posted 1912; $1-2.

Posted 1912; $1-2.

Copyright 1912; $2-3.

Message on reverse:
"Try and come up you and your Son to see our Christmas tree some time through the holidays. Emma."
Posted 1912; $1-2.

Posted 1912; $1-2.

A Joyful Christmas

Christmas Blessings on thee shine. And joy and Peace be always thine

Posted 1912; $1-2.

A Merry Christmas

Posted 1912; $1-2.

A MERRY CHRISTMAS

Posted 1912; $1-2.

BEST CHRISTMAS WISHES

CHRISTMAS GREETINGS

Tuck and Sons
Posted 1912; $2-3.

Posted 1912; $1-2.

Posted 1912; $1-2.

Posted 1912; $1-2.

Posted 1912; $1-2.

Posted 1912; $1-2

Posted 1912; $6-7.

Tuck and Sons
Posted 1912; $4-5.

Posted 1912; $1-2.

Posted 1912; $1-2.

Posted 1912; $4-5.

Posted 1912; $2-3.

Tuck and Sons
Posted 1912; $2-3.

Hand-written date 1912; $1-2.

Tuck and Sons
Posted 1912; $1-2.

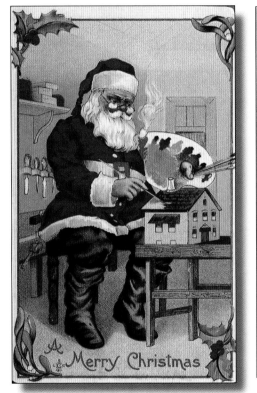

Undated; $8-10.

Posted 1912; $1-2.

Posted 1912; $1-2.

May Christmas-tide
Bring sunshine in its train
Its glow remain
Till Christmas comes again

Posted 1912; $1-2.

Undated; $6-8.

Wishing you A Merry Christmas

Posted 1912; $1-2.

With Hearty Greetings and all Good Wishes for the New Year

Hand-written date 1912; $1-2.

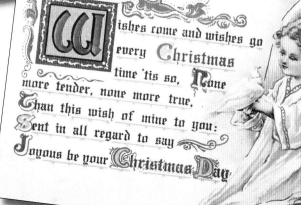

Wishes come and wishes go every Christmas time 'tis so, None more tender, none more true, Than this wish of mine to you: Sent in all regard to say Joyous be your Christmas Day

Undated; $2-4.

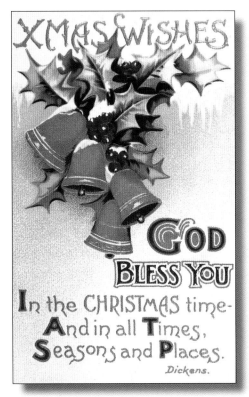

Posted 1912; $1-2.

John Winsch
Posted 1912; $1-3.

Posted 1912; $1-2.

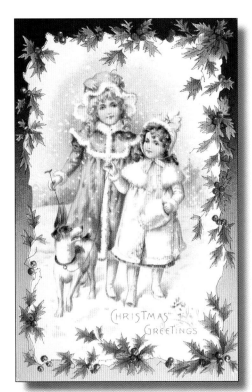

Undated; $4-5.

Posted 1912; $3-4.

Posted 1912; $1-2.

Posted 1912; $1-2.

Posted 1912; $1-2.

Posted
1913; $1-2.

Posted 1912; $1-2.

Hand-written date 1913; $6-8.

Posted 1913; $1-2.

Bernard Wall
Copyright 1912; $3-4.

Undated; $5-6.

Posted 1913; $1-2.

Posted 1913; $1-2.

Posted 1913; $1-2.

A XMAS WISH

That naught but good and pleasure befall thee, friend.

Posted 1913; $1-2.

May your Christmas day be joyous,
May your heart be filled with cheer,
May old Santa bring you pretty things
Enough to last a year!

416B

Undated; $6-8.

Hello-Merry Christmas

Posted 1913; $5-6

A Blessed Christmastide.
"Silent night! holiest night!
Wondrous Star, O, lend Thy light!"

Posted 1913; $2-4.

SEASONS GREETINGS

With heaps of joys of every kind,
May merry Christmas come,
And bring sweet pleasures to your mind,
And gladness to your Home.

Posted 1913; $5-6.

A MERRY CHRISTMAS

Posted 1913; $1-2.

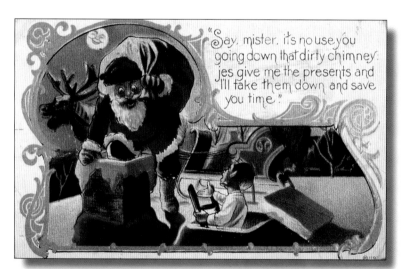

"Say, mister, it's no use you going down that dirty chimney; jes give me the presents and I'll take them down and save you time."

Undated; $6-8.

A MERRY CHRISTMAS

Posted 1913; $2-3.

A MERRY CHRISTMAS

To-day may only looks of love.
Beam on you as you go, . . .
And only words of joy and cheer
From fond hearts overflow.

Posted 1913; $1-2.

A MERRY CHRISTMAS

Over the wire I have made connection
To send a message in your direction.

C-65

Posted 1913; $3-4.

Undated; $1-2.

Posted 1913; $1-2.

Posted 1913; $1-2.

Posted 1913; $1-2.

Copyright 1913; $4-5.

HERE'S TO YOU!

〰〰〰〰〰

I hope your stockings 'll be so full
Of lumpy, humpy things,
You'll have that funny feeling
As if something in you sings.

Undated; $2-3.

Christmas
Greeting

913

MH

Posted 1913; $3-4.

Christmas
Greetings

Posted 1913; $1-2.

Christmas Wishes

Time's swift
streamlet
deep and wide,
Still rushes on
from year to year
And once again
at Xmas-tide
I pray God bless
and keep you dear.

DESIGN COPYRIGHTED JOHN WINSON, 1913

Posted 1913; $1-2

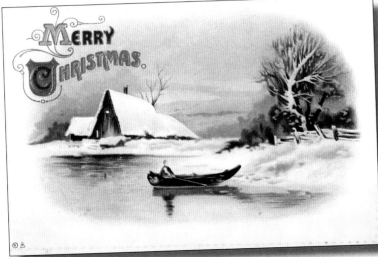

MERRY
CHRISTMAS.

Posted 1913; $1-2.

110

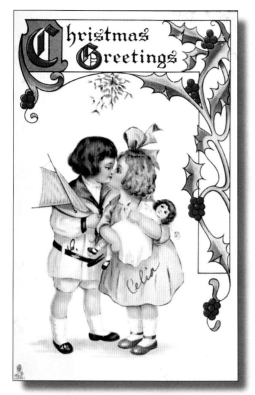

Message on reverse:
"Dear Cousin, If you are a good little girl
and your hang up your sock on Xmas
Eve, I think Santa will put the doll in the
sock. I am having a good time in the city.
We have nice weather."
Posted 1913; $7-8.

Posted 1913; $3-4.

Hand-written date
1913; $1-2.

Posted 1913; $1-2.

Copyright 1913; $2-3.

111

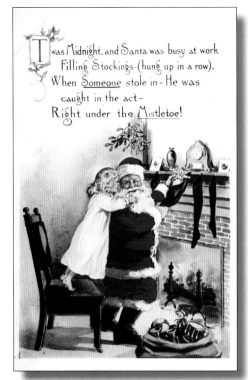

'Twas Midnight, and Santa was busy at work
Filling Stockings-(hung up in a row).
When Someone stole in- He was
caught in the act-
Right under the Mistletoe!

Posted 1913;
$3-5.

Christmas Wishes.

So many dear wishes I hold for you,-
Christmas wishes, all fond and true,-
That I cannot mention them all, my friend-
On the card of greeting I herewith send.
So I let them loose on the wings of Thought:
With "Merrie Christmas!" each one is fraught.
Long life! good health! and plenty of friends!
Accept the greetings my friendship sends.
Mary D. Brine

From Meal

Posted 1913; $1-2.

Hand-written date 1913; $1-2.

Greetings full of hearty cheer
Christmas Greeting
♥ awaits you here. ♥♥

Hearty good wishes —
— for a —
Bright and Happy —
Christmas —
From

Posted 1913;
$2-3.

A MERRY CHRISTMAS

A very merry Yule

Hand-written date 1913; $1-2.

Posted 1913; $1-2.

Posted 1913; $1-2.

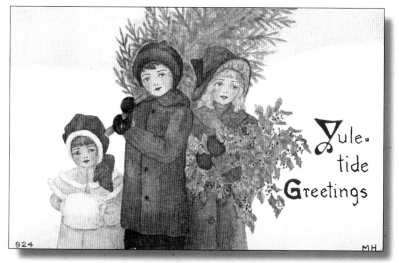

Posted 1913; $2-3.

Posted 1914; $1-2.

Posted 1913; $1-2.

Posted 1914; $1-2.

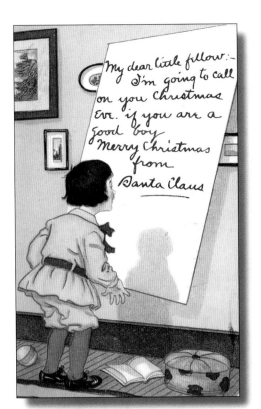

Undated; $3-4.

Posted 1914; $1-2.

Posted 1914; $1-2.

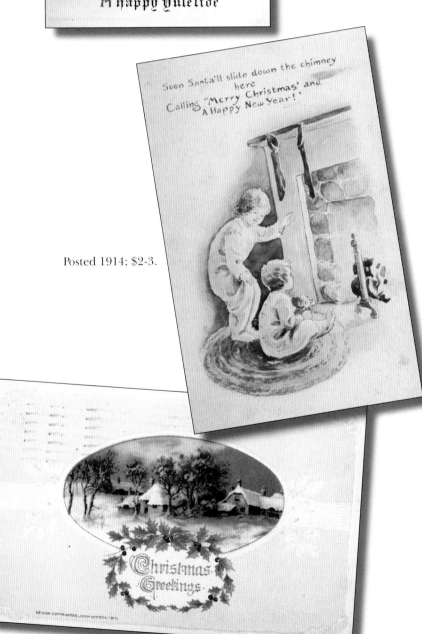

Posted 1914; $2-3.

John Winsch
Posted 1914; $1-2.

Posted 1914; $1-2.

Posted 1914; $3-4.

I WISH YOU A MERRY CHRISTMAS

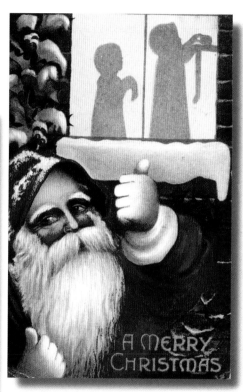

A MERRY CHRISTMAS

Undated; $5-6.

Posted 1914; $2-3.

Posted 1914; $1-2.

Posted 1914; $1-2.

Posted 1914; $1-2.

Message on reverse:
"Merry Xmas and Happy New year to you. We are all well as usual but Ma is poorly. We have having some real winter now for sure. I want to get to Macomb to get some Xmas things but it so cold— don't like to venture out. Jennie."
Posted 1914; $1-2.

Undated; $3-4.

Message on reverse:
"Dear Susie, I have waited for long for an answer to my letters, I began to believe you do not want any more like it. I wish you one of the best and happiest of Christmas's. Samantha."
Posted 1914, $1-2.

Undated; $5-7.

Undated; $3-4.

Posted 1914; $1-2.

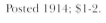

Posted 1914; $1-2.

Posted 1914; $6-8.

Undated; $8-10.

Posted 1914; $3-4.

Posted 1914; $1-2.

Posted 1914; $1-2.

Hand-written date 1914; $1-2.

Undated; $2-3.

Undated; $2-3.

Posted 1914; $1-2.

Hand-written date 1914; $8-10.

Posted 1914; $1-2.

Posted 1914; $4-5.

119

Hand-written date 1914; $1-2.

Posted 1914; $2-3.

Posted 1914; $2-3.

Undated; $12-15.

Posted 1914; $1-2.

Posted 1914; $2-3.

Tuck and Son
Posted 1914; $3-4.

Posted 1914; $1-2.

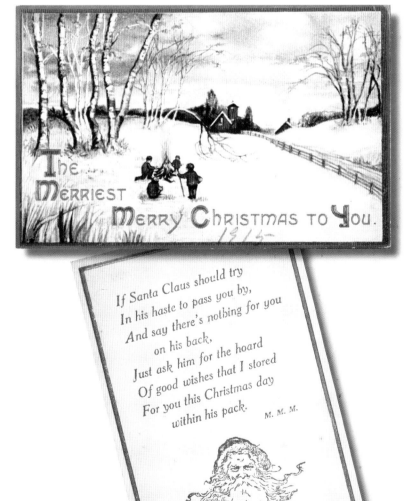

Tuck and Son
Posted 1914; $2-3.

Undated; $3-4.

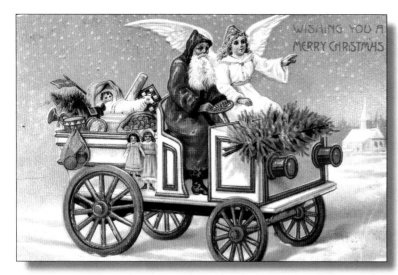

Undated; $15-18.

Posted 1914;
$1-2.

Posted 1914; $1-2.

John Winsch
Copyright 1914; $1-2.

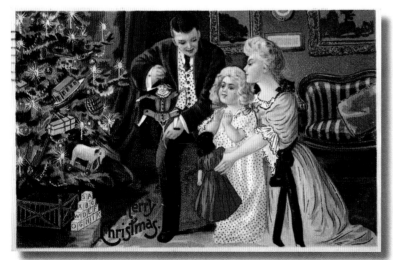

Undated; $5-7.

Posted 1915; $1-2

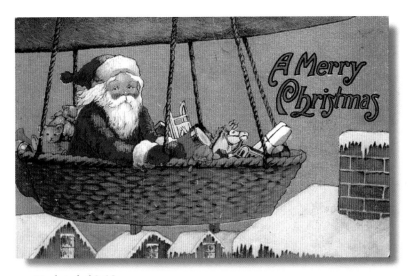

Undated; $8-10.

Posted 1915; $1-2.

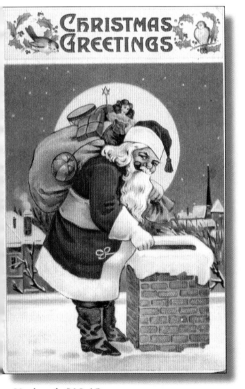

Undated; $10-12.

Posted 1915; $1-2.

Posted 1915; $1-2.

Posted 1915; $1-2.

Tuck and Son
Posted 1915; $6-8.

Posted 1915; $3-4.

Posted 1915; $2-3.

Hand-written date 1914; $3-4.

Undated; $1-2.

Standford Co.
Posted 1915; $1-2.

Twixt you and me, this Christmas-tide
the miles are stretching far and wide
But thought,
on wings unseen and free
Bears sweet remembrance, friend, to thee.

© SANDFORD CARD CO.

Merry Christmas
It's a good old wish,
That I am sending
you,
Can you guess it?
Merry Christmas!
And a Happy New Year
too!

Posted 1915; $2-3.

As the star of the east with its heaven-sent light
Guided the shepherds that Christmas night
To the place where the Christ-child lay,
So may the candle of Christmas cheer
Lighten your pathway each day
of the year
With a joyous and
peaceful ray!
M. C. G.

Posted 1915; $2-3.

To Wish You
A Very
Happy

CHRISTMAS

Undated; $22-24.

Undated; $2-4.

Undated; $2-4.

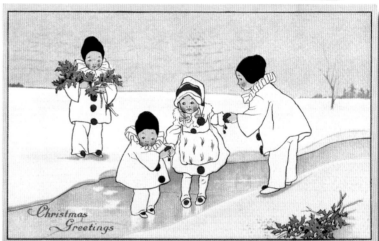

Posted 1915; $3-4.

John Winsch
Posted 1915; $1-2.

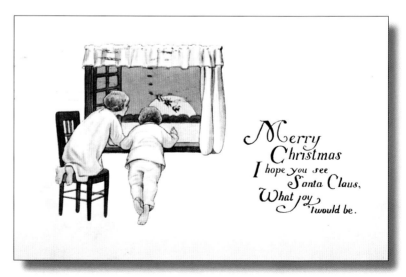

Posted 1915; $2-3.

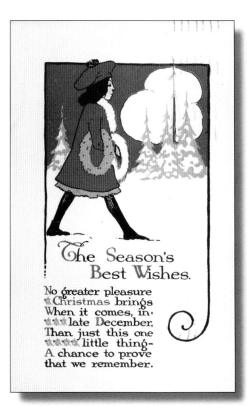

The Season's Best Wishes.

No greater pleasure
Christmas brings
When it comes, in
late December,
Than just this one
little thing—
A chance to prove
that we remember.

Posted 1916; $2-3

Posted 1916; $2-3.

Merry Xmas
I wish you,
In the very best
of style
With a stocking
full of Goodies
And a festive
jolly smile.

HELLO! MERRY CHRISTMAS!

I MIGHT SAY MORE BUT IT WOULDN'T MEAN MORE.

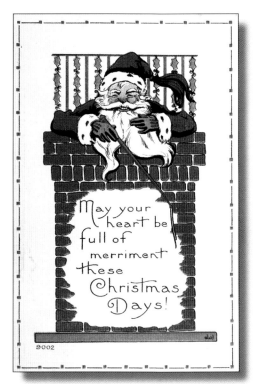

May your heart be full of merriment these Christmas Days!

9002

Posted 1916;$5-7.

Posted 1916; $2-3.

A Christmas Wish For You.
I haven't felt so
happy
Since Christmas last was due
As now while I am making
A Christmas wish for you.
Merry Christmas.

454D

Message on reverse:
"I've been just awful busy for the last week or two. But I'll drop a line to you. May you have a Merry Xmas and may the New Year hold more bright days for you than any you have known."
Posted 1916; $1-2.

127

BEST CHRISTMAS WISHES

May the music of the chimes
Ring you glad and happy times,
And their voices clear and sweet,
Unto you my wish repeat.

Posted 1916; $2-3.

A Merry Christmas

Posted 1916;$1-2.

Posted 1916; $2-3.

Christmas Tidings

Undated; $3-4.

To You & Yours— A "DANDY" CHRISTMAS!

A Merry Christmas

MERRY CHRISTMAS

Undated; $6-9.

Posted 1916; $1-2.

A Real Merry Christmas and a Joyous Holiday time

Posted 1916; $1-2.

Merry Christmas Bells Are Ringing

Posted 1916; $1-2.

Posted 1916; $1-2.

A Merry Christmas

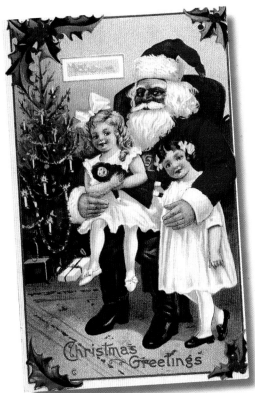

Christmas Greetings

Undated; $6-8.

Message on reverse:
"We have been here a year and all are well and having a good time. Hope you have had plenty of coal. Weather is warmer and working steady. Faye and Warner."
Posted 1916; $2-3.

Christmas Greetings from California

Pepper Tree and Orange Grove

A Christmas scene--the snowy peaks
Against a cloudless sky,
And blooming flowers everywhere
To gladden heart and eye.

Posted 1916; $1-2.

Posted 1916; $1-2.

Posted 1916; $1-2.

Posted 1916; $1-2.

Posted 1916; $1-2.

A JOYFUL CHRISTMASTIDE

May Christmas have for you
in store
Health and Happiness galore.

Posted 1916; $2-4.

May Christmas
with its
magic spell
Make all things happy,
all things well.

Posted 1916; $1-2.

Here's a Merry Christmas
straight
from me and
Santa Claus!
I hope 'twill be the
merriest that
ever,—ever was.

Elizabeth Hasemeier

P.F. Volland
Posted 1917; $2-3.

With all kind thoughts
and wishes for a
Merry Christmas

Posted 1917; $1-2.

With a load of best
Christmas Wishes

Posted 1917; $4-5.

Wishing You a Merry
Christmas

Posted 1917; $1-2.

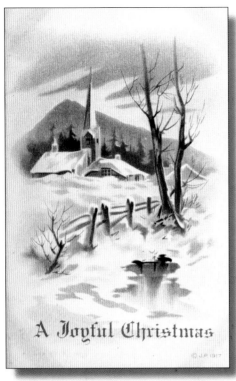

A Joyful Christmas

Hand-written date 1917; $1-2.

A Joyous Christmas

Posted 1917; $1-2.

CHRISTMAS GREETINGS

Christmas Day is for the young,
When the little stockings hung
Santa Claus, the good old Saint,
Listens to each childish plaint.

Message on reverse:
"I am better than what I was. Harry is
writing to his folks, and they are come
up Wed., and get that meat. Will you
send two gallon of lard along with them
Take it over Tues. evening."
Posted 1917; $2-3.

CHRISTMAS GREETINGS

May Christmas with all its joys and toys
Bring happiness to little girls and boys

Undated; $2-3.

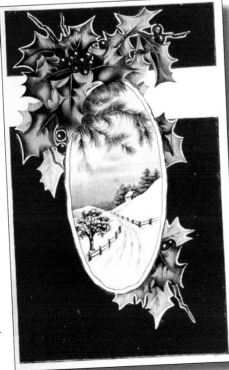

Whitney
Posted 1917; $1-2.

Knocking at your door with
CHRISTMAS GREETINGS

Margaret Evans Price
Handwritten date, 1917; $3-4.

Posted 1917; $1-2.

Undated; $2-3.

Undated; $2-3.

Posted 1918; $3-4.

Handwritten date 1917; $2-3.

Posted 1917; $1-2.

Posted 1918; $1-2.

Posted 1918; $1-2.

Posted 1918; $1-2.

Posted 1918; $4-5.

A JOYOUS CHRISTMAS

Whatever it takes to make your day glad,
I wish from a heart both joyous and sad.
The Joy for our Friendship that grows day by day,
The Sadness because you are so far away.

Posted 1918; $1-2.

FROM FRIEND TO FRIEND
Should Christmas
bells forget to chime,
And Christmas
carols fail you,
May just this bit
of cheerful rhyme
With Friendship's
greeting hail
you

Posted 1919; $1-2.

493 B

Posted 1919; $5-6.

Posted 1918; $1-2.

Posted 1919; $5-6.

Christmas
If wishes only would come true
And beg him to reserve for you

Cheer
I'd go to dear old Santa
His nicest things, instanta

Posted 1919; $4-5.

Posted 1919; $1-2.

GREETINGS from CALIFORNIA

If you can wish
for a better
Christmas
than the one
I am wishing
for you—may it
be yours—

MERRY
CHRISTMAS

BUNGALOWS
AND FLOWERS
IN WINTER

Posted 1919; $2-3.

To Wish You
Christmas Joy

Dear friend, this card is small,'tis true,
But the good wish is great that it
brings to you!

Posted 1919; $1-2.

Best
Wishes
for a
Happy
Christmas

Posted 1919; $1-2.

A Merry Christmas

Tender thoughts and
memories sweet
Recall "the old fashioned
country-seat."
And now once more, as in
days of yore,
My Christmas greetings go
straight to its door.

Posted 1919; $1-2.

Decade 1920 - 1929

Children enjoy sending Christmas Postcards. They increase good will and the spirit of the season.

 Montgomery Ward catalog, 1922.

They called the decade of the 1920s "the Jazz Age"—among other things.

It was also the age of coonskin coats, crossword puzzles, and Babe Ruth. Prohibition and its accompanying bathtub gin, speakeasies, bootleggers, moonshine, and gangsters, further shaped it.

Families in the immediate Pittsburgh area with very new crystal radio sets would tune in to hear results of the Presidential election in 1920. The KDKA signal was faint, but the margin was strong. Warren Harding defeated James Cox handily.

Beauty had a new dimension in the 1920s. The first Miss America beauty pageant was held in Atlantic City during September of 1921. Not only were one-piece bathing suits permitted, but bare legs were also allowed. Gone were the days of pajama-like swimsuits and stocking clad displays—at least in beauty contests.

The Montgomery Ward mail order catalog of 1922 was jammed with bargains. For the fashionable ladies all wool Polo Coats sold for $12.75, "smart" women's suits ranged from $12 to $31, and an all wool striped worsted suit for men was $35.

Santa's Train Shop midway in the thick catalog offered an entire electric train outfit complete with three-way transformer for $7.98. Santa, looking very traditional, and two elves appeared at the top of the page. Montgomery Ward also had two full pages of Christmas decorations that year.

But perhaps the most intriguing aspect of the massive catalog was its offering of Christmas postcards. They were still big business. A package of twenty-five children's Christmas postcards was offered for seventeen cents. Within the package were "charming designs in colors for children." The catalog gently stressed the idea of sitting down children to personalize Christmas postcards much as their parents had done and should continue to do.

Next to that section was a selection of Christmas postcards for grownups. It boasted of "artistic colors and designs." Further, it promised "a series of decorated Christmas postcard messages which breathe in the Christmas spirit." Price for a package of sixteen was eighteen cents. Still another offering, somewhat less expensive, was a group of thirty Christmas postcards for twenty-three cents. Proclaimed the catalog:

"These cards have bright colors. Santa Claus and other designs included. All embossed on good stock."

Other places sold Christmas postcards too. They were a seasonal seller in so-called dime stores, otherwise known as variety stores. Such stores prospered in part because of the decade's dramatic chain store connection. By the end of the decade, ninety-three percent of those stores were chain store related. Big retail names nationwide included Woolworth's, United Cigar Stores, and Walgreen's. Nearly twenty percent of drugstore sales were chain-generated as well as twenty-seven percent of food sales.

Meanwhile the younger generation of this remarkable decade danced the Charleston, played the ukulele, wore flapper styles, and general rebelled against all things mainstream.

For women short hair became a fashion statement too. Bobbed hair suddenly became becoming. Nearly all of the spring hats were so small that only bobbed cut heads could find into them. Large hats were out, as well as the long hair fashion for women. As a consequence, women "invaded" men's barbershops seeking sleeker, short-trimmed haircuts.

In 1925 the classified ads of the *New York World* were promising. One sought a chambermaid at a nurse's training school. Wages were $40 per month. Another advertised for a "male clerk" with time-keeping experience. Applications were required to state age, experience, and religion. Pay was $110 per month.

That same year there were seventeen million automobiles in the United States. There were 20,000 miles of concrete roads. Overhead the United States Post Office expanded its airmail service by contracting with private airlines. There were, by the way, forty-eight airlines then doing business in 355 American cities.

Nearly two thirds of American homes had electricity by 1927. And they used it. Some twenty-five percent had washing machines, fans, or toasters. Some thirty-seven percent had electric vacuum cleaners, and a solid eighty percent had electric irons.

In May of 1927, Charles A. Lindbergh took off in his airplane, The Sprit of St. Louis, from a New York airport. Just over thirty-three hours later he landed safely at Le Bourget Field in Paris, France. He was not the first to fly the Atlantic Ocean, but he was the first to fly it alone. The world was astounded. Lindbergh became both famous and rich.

The nation's first coast to coast roadway, The Lin-

coln Highway, opened that same year even though sections of it were still dirt covered. In the air, the sleekest commercial aircraft was the Ford tri-motor airplane. It carried ten passengers. On Main Street, Al Jolson starred in the nation's first talking picture—*The Jazz Singer*.

Despite the progress and prosperity, most people of the 1920s were not rich. In 1929, an income of $6,000 was considered rich. The fact is ninety-five percent of Americans were struggling on much less annually. Some sixty percent of the nation's families had a household income of less than $2,000. Further, more than twenty percent received less than $1,000 per year in income.

In the stock market, the Great Crash came in October of 1929. The market had been slipping downward for weeks, but in a single day it lost fourteen billion dollars in value. Ultimately in less than a month it lost thirty billion dollars.

Still Christmas was Christmas. And Christmas postcards were a part of it for the entire decade, if perhaps in somewhat dwindling numbers.

Hand-written date 1900; $2-3.

CHRISTMAS GREETINGS

I've put the children to bed
And here in the candle light
I'll wish you a merry Christmas
And now I must say good night.

A merry Christmas
X 658-3.

Undated; $6-9.

A happy CHRISTMAS To you

Undated; $8-10.

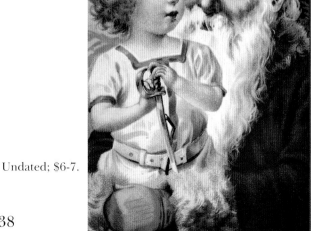
Undated; $6-7.

CHRISTMAS GREETINGS

Everything that's good for You, may this Christmas morning bring

Posted 1920; $1-2.

Undated; $1-2.

Undated; $1-2.

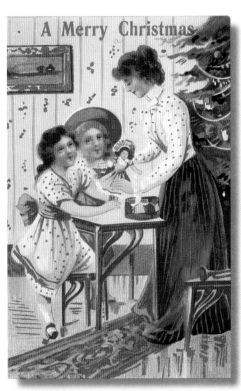

Undated; $3-5.

Undated; $3-4.

Posted 1920; $1-2.

Undated; $3-4.

139

Undated; $1-2.

Undated; $1-2.

Undated; $1-2.

Posted 1920; $1-2.

CHRISTMAS WISHES

MAY YOUR CHRISTMAS
PRESENTS PROVE THAT
SANTA IS NO PIKER.

Posted 1920; $2-3.

Undated; $3-4.

Undated; $12-15

Posted 1920; $1-2.

Undated; $3-4.

Undated; $3-4.

Undated; $3-4.

Posted 1920; $1-2.

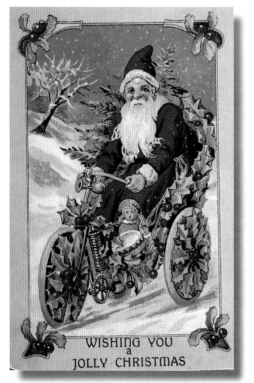

WISHING YOU a
JOLLY CHRISTMAS

Undated; $6-9.

Just a Christmas Greeting
with Best Wishes
From all of us to all of you—

Posted 1920; $1-2.

Undated; $6-8.

A Happy Christmas to You

Message on reverse:
"Dear Sister, I would like to drop in and help you on that big turkey for Xmas dinner. I shall think of you all at dinnertime. You sister, Mayme."
Posted 1920; $1-2.

CLAUS

A Merry Christmas

Merry Xmas
Sleighbells, and holly, and pudding, and boys,
A fine combination of Xmas joys —
Here's hoping your shadow may never grow thinner
For lack of a comforting Xmas dinner!

Agnes Ketcham
Undated; $4-5.

A JOYFUL YULETIDE.

142

Undated; $3-4.

May your Christmas day be joyous,
May your heart be filled with cheer,
May old Santa bring you pretty things
Enough to last a year!

1921 Christmas Seal
Posted 1921; $2-3.

Undated; $2-3.

A Merry Christmas.

A Joyful Christmas
Let naught dismay,
For Christ our Lord was born to-day.

Undated; $1-2.

A Christmas Greeting
With gold and myrrh
and frankincense
Came Wise Men
To lay their offerings
at His feet.

M. Dulk
Posted 1921;
$2-3.

"Merry Christmas"
The new old greeting
of peace and good will on earth.

Undated; $1-2.

CHRISTMAS GREETINGS

Message on reverse:
"Dear Grandma, We are all well and hope
you are the same. It is cold out here; it was
12 below zero Wednesday morning. Write
soon, Ruth."
Undated; $1-2.

143

You have my best wishes for a very merry Christmas

Undated; $1-2.

CHRISTMAS GREETINGS
There's a little house I hope will be Abrim with CHRISTMAS Cheer and Glee, From the Chimney top to the Basement Floors, And that dear House, of course, is Yours.

Posted 1921; $1-2.

A CHRISTMAS WISH

It's surely worth repeating,
So this merry day I send-
A Christmas wish for happiness
That will never have an end.

Undated; $1-2.

Christmas Greeting.

Oh, how something would be beating,
If your eyes and mine were meeting
While I give this hearty greeting -
"Merry Christmas!"

Undated; $1-2.

Christmas Greetings

In, sending friends a greeting
I may forget a few
But there is one thing certain
It never will be you

Undated; $2-3.

Hand-written date 1922; $1-2.

A Merry Christmas

Undated; $4-5.

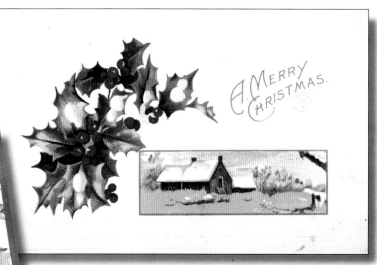

Posted 1921; $2-3.

Posted 1921; $1-2.

Message on reverse:
"Dear Cousin, It is snowing at present. I got a ring for Xmas. You ought to have been here and went to the Xmas tree. You ought to be here to help hover the fire. I wish you a happy new year, Gladys."
Undated; $1-2.

Hand-written date 1921; $1-2.

Undated; $1-2.

MERRY CHRISTMAS
My wish is big, my card is small,
But Merry Christmas one
and all.

Undated; $3-4.

My prayer for you this joyous Day:
May Happiness attend you.

Hearty Christmas
Greetings

Undated; $1-2.

Posted 1922; $1-2.

Heaps of fun, on
CHRISTMAS!

Buster.

Posted 1922; $3-4.

Just a little CHRISTMAS
greeting. Wish it were
CHRISTMAS meeting.

A Merry Christmas

Undated; $1-2.

Undated; $1-2.

Best Wishes
for
Christmas.

Christmas Greetings, warm and true.
Fragrant with kind thoughts of you.

Undated; $1-2.

May Christmas Joys Be Thine

Undated; $3-4.

Merry Christmas

While resound Merry Chimes,
Bringing thoughts of
Peace Goodwill.
Be your Christmas many times
Brighter than all Seasons still.

Undated; $1-2.

Cheerful looks and words are very
Sure to make the Christmas merry

Undated; $3-4.

Christmas Joys
for Father:

All that will make
you glad and gay,
All that will bring you
peace and cheer:
I'm wishing for your sake today,
A Christmas blessing
Father dear.

Undated; $2-3.

Sincere wishes for a joyous Christmas-tide

Merry Christmas

Since Santa comes but once a year,
I rejoice when he is here.
For then I send best wishes true
Christmas Greetings straight to you.

Posted 1922; $6-8.

Posted 1922; $1-2.

Greetings
To You
and all your family
from all of mine,
For the merriest Christmas, with love
in every line!

Posted 1922; $1-2.

A Very Merry Christmas

Posted 1922; $3-4.

Christmas Wishes.

May Christmas give
such pleasure true
And mirth and cheer
and joy to you,
That you will think
of it for weeks,
With happy eyes
and smiling cheeks.

How very happy I should be
If you were only here with me
To help me light my candles
And play around my Christmas
—tree—

Posted 1922; $3-4.

Undated; $1-2.

Merry Xmas
Life may have its ups and downs
But as Christmas time draws ne[...]
The World does seem a good plu[...]
Our Friendship to us more dear

A Christmas Wish
for you.

As this bright candle
throws out its rays,
So may friendships'
warm beams light
all your days.

Posted 1922; $1-2.

Hand-written date 1923; $2-3.

148

CHRISTMAS GREETINGS

Santa's always busy,
But he promised me he'd stop
And fill your Christmas stocking
From the bottom right to the top.

Posted 1923; $4-5.

The Season's Greetings
and a load of Christmas wishes for you all

Undated; $2-3.

Here comes a
message of
Good Cheer, and
A Merry
Christmas

Undated; $2-3.

Heartiest Greetings

May the bright
Christmas Candles
be emblems

of the
brightness of
your future.

Posted 1923; $1-2.

With all my best
wishes for a
Very Merry
Christmas.

Undated; $2-3.

CHRISTMAS GREETINGS

HARK!

Undated; $3-4.

149

MERRY CHRISTMAS

MAY EACH HOUR THE
YULETIDE THROUGH
FIND GLADNESS IN
YOUR HEART

Posted 1923; $1-2.

Upon your step
I'd like to stand
Your door-bell loudly ring, and when you'd
come, I'd shake your hand and shout like
anything "MERRY CHRISTMAS"

Message on reverse:
"Dear Cousin, Oh how I would love to see you and I would
love to have you with us for Xmas dinner. We are all well
but Hazel had the Gripp or Flue and is just getting over it."
Undated; $1-2.

Over and over, year after year
I carry the same old message of
cheer MERRY CHRISTMAS

Posted 1923; $1-2.

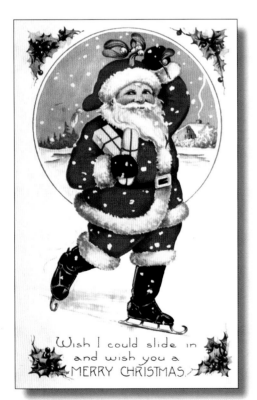

Wish I could slide in
and wish you a
MERRY CHRISTMAS

Undated; $4-5.

A MERRY CHRISTMAS and many
more A happier NEW YEAR than
ever before

Undated; $1-2.

I'M YOUR FRIEND
ALL TWELVE MONTHS THROUGH
AND BECAUSE I AM, I'M WISHING YOU

A VERY MERRY CHRISTMAS

Undated; $1-2.

Undated; $6-7.

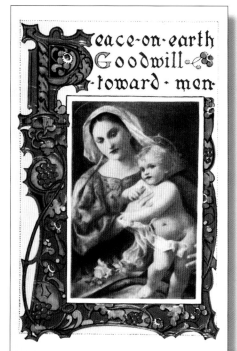

Undated; $2-3.

Undated; $2-3.

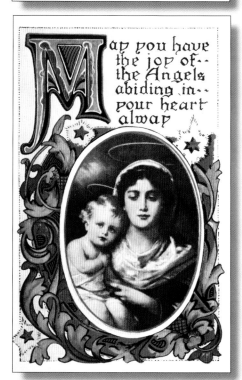

Undated; $2-3.

Posted 1923; $1-2.

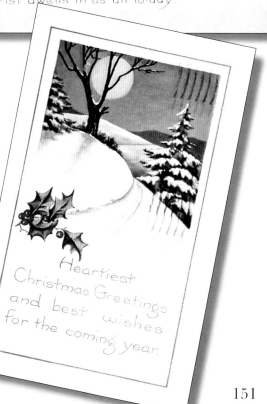

151

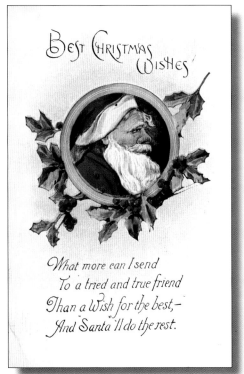

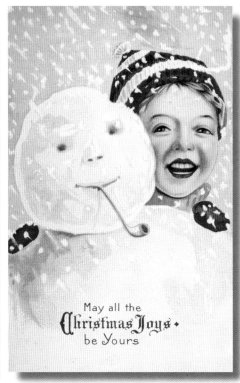

Posted 1923; $3-4.

Posted 1923; $3-4.

Undated; $1-2.

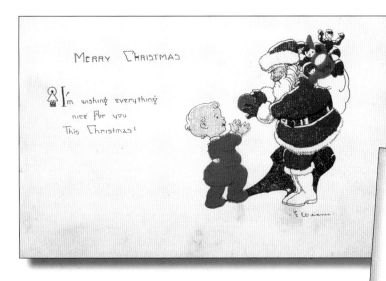

E. Weaver
Hand-written date 1923; $3-4.

Hand-written date 1923; $1-2.

Undated; $1-2.

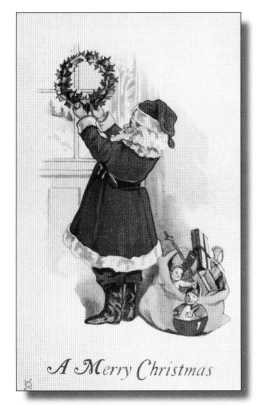

Undated; $5-6.

Undated $1-2.

Posted 1923; $10-12.

Posted 1923; $3-4.

Posted 1923; $1-2.

Posted 1924; $2-3.

CHRISTMAS GREETING

The warm heart laugh[...]
at the winter's ch[...]
And aglow with t[...]
season's glad good [...]
May your heart be this Christm[...]

Now comes
the good old
Christmas time.
I wish that you
were here!
Since that can't be
I send this rhyme
With greetings
most sincere

Posted 1924; $1-2.

Undated; $6-7.

A MERRY CHRISTMAS TO YOU

O may this truth to all be clear
That Christmas is the best day of the year,
For then we put ourselves from sight
That other lives be made most bright.

Posted 1924; $3-4.

Posted 1924; $3-4.

Posted 1924; $18-20.

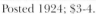

Christmas Greetings

Hand-written date 1924; $1-2.

A JOYFUL CHRISTMAS

Undated; $1-2.

Undated; $2-3.

Posted 1924; $2-3.

Undated; $2-3.

Undated; $1-2.

Undated; $2-3.

CHRISTMAS WISHES

When Santa comes on this year's trip
And stops before your door,
I hope he leaves just everything
That you've been wishing for.

Posted 1924; $5-6.

We're wishing you
a glad New Year
And the merriest
Christmas yet

Posted 110; $1-2.

Undated; $2-3.

WISHING YOU A JOLLY CHRISTMAS

Gibson Art Co.
Undated; $2-3.

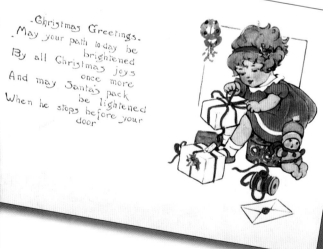

-Christmas Greetings.
May your path to-day be
brightened
By all Christmas joys
once more
And may Santa's pack
be lightened
When he stops before your
door.

Posted 1925; $2-3.

Christmas Greetings

Undated; $1-2.

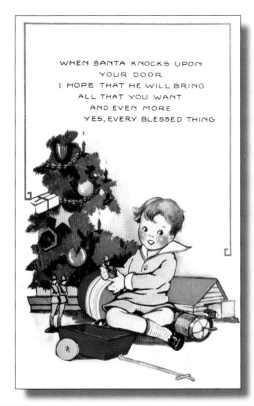

WHEN SANTA KNOCKS UPON
YOUR DOOR
I HOPE THAT HE WILL BRING
ALL THAT YOU WANT
AND EVEN MORE
YES, EVERY BLESSED THING

Hand-written date 1926; $2-3.

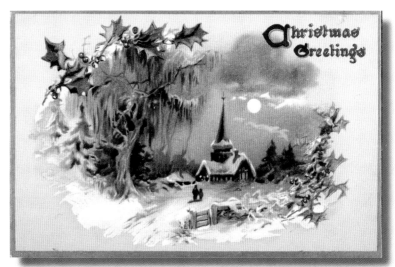

Christmas Greetings

Tuck and Sons
Undated; $1-2.

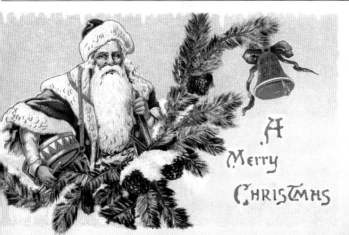

A Merry CHRISTMAS

Undated; $2-3.

MERRY MERRY CHRISTMAS

Gibson Art Co.
Hand-written date 1926; $2-3.

May every Christmas
find our friendship
As tender and full of
comfort as it is today.

Posted 1928; $1-2.

Undated; $5-7.

A Merry Christmas

504

B. Wall
Undated; $2-3.

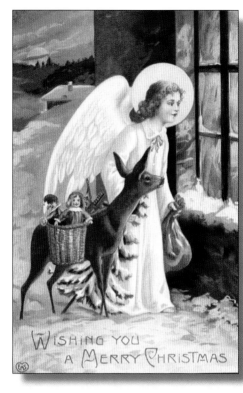

WISHING YOU A MERRY CHRISTMAS

Undated; $4-5.

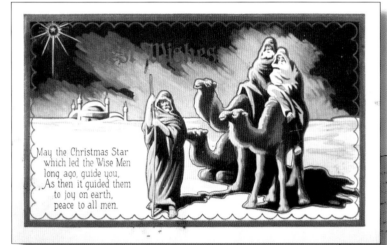

May the Christmas Star which led the Wise Men long ago, guide you, As then it guided them to joy on earth, peace to all men.

Undated; $6-9.

MERRY CHRISTMAS

All that's bright and beautiful,
Happy, wholesome, too,
I'm hoping very earnestly
This Christmas offers you.

Posted 1928; $1-2.

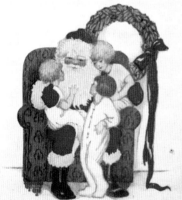

MERRY CHRISTMAS
To you I wish
a little more
Than to anyone I know
That happiness
from Santa's store
May in abundance flow!

413-B

Hand-written date 1928; $2-4.

MERRY CHRISTMAS

Posted 1928; $5-8.

Undated; $2-3.

Posted 1928; $1-2.

Hand-written date 1928; $1-2.

Undated; $5-7

Undated; $8-10.

Undated; $3-4.

Decade: 1930s & Beyond

The decade of the 1930s was in trouble even before it started. Around Christmas of 1929, United States Senator James Couzens grimly reported to the Michigan Manufacturers Association that unemployment had become a tidal wave. Between the Big Crash of October and the Yuletide season, the number of jobless had climbed from 700,000 to well over three million.

Some estimates suggest unemployment got unbelievably worse as the months of 1930 went by and was in the range of twelve million by December of that year. What is known for sure is that thousands of people were selling apples on street corners that Christmas season. The practice had started in New York City as November closed in and then spread to other American cities.

Still, for all of its gloom and doom, the decade of the 1930s did have some bright spots. It was an era that ushered in the nylon toothbrush, the nickel glass of beer, big bands, supper clubs (for those who could afford it), the Flip Flop toaster, chain letters, miniature golf, and Wag Coffee.

Retail prices were low and going lower. Piggly-Wiggly Stores advertised Land O'Lakes butter for fifty-four cents a pound, and coffee for twenty-nine cents a pound. Prime rib roast was thirty-five cents a pound and country fresh eggs were thirty-five cents a dozen. Less than two years later, that same group of chain stores would offer not one but two-dozen eggs for forty-one cents.

There was little to sing about but still there was singing. In 1931 the nation's hit song was the upbeat, "Life Is Just A Bowl of Cherries." One year later, the hit song was a more remorseful, "Brother, Can You Spare a Dime."

By 1932, the average family income had declined from the $2,300 it averaged just as the decade began to a bleak $1,600. There were fewer millionaires too. In early 1930 the number filing such tax returns was over 500. By late 1932 only twenty people in the country were listing themselves as millionaires.

Christmas inched by in 1932, and then despite it all came the inevitable post Christmas sales. In New York City, a newspaper advertised after Christmas buys which included double cotton sheets for eighty-four cents, Turkish bath towels for thirty-four cents, men's derby hats for $2.75, and men's overcoats for $16. As an after Christmas bargain one store offered corsets for women and misses marked down from $69.50 to $19.50.

Women's fashions had changed with times as well. Somewhat less expensive materials were used during the decade for fancy clothing. The boyish appearance of the bobbed-cut Flapper girl of the 1920s gradually moderated. In its place was rebirth of buttons and bows, ruffles, and curving lines. Small hats gave way to larger hats. Even wearing bows in the hair was fashionable.

Banks closed by the thousands, while other businesses closed by the tens of thousands annually.

A few things seemed to overcome even the bleakest of economic news. A price war broke out one Christmas season and cigarettes sold for ten to twelve cents a pack. Cigarette consumption meanwhile went from 23 billion yearly in 1930 to 158 billion yearly by 1936. People bought gasoline too. During the early years of the Great Depression the number of gas stations stubbornly nearly doubled. And yet the total sales of gasoline hardly wavered.

Movies were big too. Admission to most any movie theater in most any American town was twenty-five to thirty-five cents. Besides the air-conditioning, there were silver-screen treats like *Gold Diggers* of 1933, *Little Caesar*, *Gone With The Wind*, and (fondly) *The Wizard of Oz*.

For those interested in other forms of recreation, newspapers advertised a round-trip from New York to Boston via Fall River Line for $7.50. Also available was a sixteen-day Caribbean Cruise via the Italian Line for $205.

Mostly, however, people dealt with little work and horrible weather. In 1936 the Midwest sustained its coldest winter and likewise its hottest summer. Dust storms, droughts, and flooding joined forces. Thousands of people fled the barren and dusty landscape of the Midwest for the seemingly greener pastures of California, Oregon, and Washington. By 1940 more than one million Americans had migrated to the western borders of the nation.

Citizens entered the new decade in 1940 searching for optimism in the U.S. while the drumbeat of World War II was heard in Europe and Asia. For the most part, the era of the Christmas postcard was over, along with many other ways of American life.

With best
wishes for a
Merry Christmas
and a happy pros
perous New Year

Posted 1930; $1-2.

ALL CHRISTMAS HAPPINESS AND GOOD CHEER
TO YOU AND YOURS

Posted 1930; $1-2.

May the star that led the Wise
Men of old, shed its light on
your home this Happy Christmas
time.

Posted 1930; $1-2.

Best
Christmas
Wishes

Undated; $2-3.

Seasons Greetings

Undated; $2-3.

A Merry Christmas
Here's a Christmas Greeting true
That's gladly sent from me to you

Posted 1931; $1-2.

Christmas
Gladness
and
New Year
Blessings

For unto you is born this day in
the city of David a Saviour, which
is Christ the Lord Luke 2:11

Posted 1932; $1-2.

To let you know I wish
you a very MERRY
CHRISTMAS and
that I hope the NEW
YEAR will be filled
with happiness for
you

Undated; $1-2.

The oldest wish
and the best
Merry Christmas

Posted 1931; $1-2.

CHRISTMAS GREETINGS TO MOTHER AND FATHER.

I HOPE THE SACRIFICES MADE,
AND LOVE FOR ME EXPREST,
RETURN TO YOU ON CHRISTMAS DAY,
IN BLESSINGS OF THE BEST;
AND, MOTHER DEAR AND FATHER DEAR,
WHEREVER I MAY ROAM,
MY HEART, I KNOW, WILL BEAT AND GROW
IN LOVE FOR YOU AT HOME.

Once more, for you.
Will this repeat
The Christmas Message.
True and Sweet.

Best
Christmas
Wishes

Undated; $2-3.

Undated; $1-2.

Undated; $1-2.

Undated; $1-2.

Message on reverse:
"The heart of me is wishing
the heart of you good cheer.
Mable."
Posted 1932; $2-3.

Posted 1933; $1-2.

Undated; $1-2.

Message on reverse:
"Dear Friend, Don't overload
your tummy with good things this
Xmas or you will be sick like I am.
Merry Xmas. Sallie."
Posted 1932; $1-2.

163

Posted 1933; $1-2.

Undated; $3-4.

Christian Herald Associa-
tion
Posted 1934; $3-4.

Hand-written date 1935;
$1-2.

Undated; $1-2.

Posted 1937; $1-2.

Posted 1937; $1-2.

Posted 1939; $1-3.

Undated; $1-2.

Message on reverse:
"Just a little card to let you known that
I will be thinking of you this Christmas.
From somewhere in the South Pacific love
to all."
Stamped, Passed By Army Examiner.
Posted 1943; $4-5.

Sterling Linder Davis Christmas
Tree, Cleveland
Undated; $2-3.

Undated; $1-3.

Other Vintage Christmas Cards

Christmas cards, that strange, bright, fascinating shower which began to rain on us early in the Victorian era, is raining yet.

The Christmas Companion, 1939

The so-called Victorian Christmas card did indeed have two lives. It abounded in America before the Christmas postcard, and it was reborn in the 1920s.

Single card Christmas greetings generally bested Christmas postcards in several ways. For one, a much better quality stiff paper was used, frequently with a sculpted or gold trimmed border. In addition, printing and engraving techniques were much more developed and use of inks was generally much more lavish.

Christmas cards, brightly printed on heavy stock, were much more expensive. During the early 1920s, such glamorous greetings sometimes retailed for as high as ten to twelve cents each while postcards went for as little as six for five cents. Consequently, despite their beauty, they were produced in far fewer numbers.

Such single Christmas cards were heavily advertised during the early 1920s in the United States. Phrases like daintily printed, beautifully engraved, rich designs, and pleasing colors were used to attract holiday shoppers.

In 1922 the Montgomery Ward catalog devoted nearly a half page of its Fall and Winter edition to Christmas cards. Only one small group was of the folded variety. All the many others were single card offerings. One such listing declared:

"Ten steel die and engraved cards with envelopes. Artistically decorated on very fine white stock. Some have decorated designs, others are plain engraved cards. Assorted sizes. Package of ten for 30 cents."

Still another listing of the mail order catalog described, "eight beautiful cards lithographed in pleasing colors. Rich in appearance. Package of eight for 30 cents." At Montgomery Ward and elsewhere during that decade they were sold at times without envelopes and at other times with envelopes.

On occasion holiday designs were mentioned in advertisements. Sometimes holly and poinsettia designs were specified. However there was generally little emphasis on the Christmas theme of the cards; advertisers instead stressed splendid color over lingering sentiment.

A number of early writers, including Ann Kilborn Cole, have noted that such cards for all of their splendor could present most any image as long as it was bright and robust. Thus birds, flowers, trees, horse-drawn coaches, and snow-covered cottages would qualify as well.

Through the 1920s and into the early 1930s, such cards often maintained however a feeling of the early Victorian era itself. Very many involved costume figures seemingly suitable to illustrated something from the pen of Charles Dickens. Fittingly so perhaps as most of Dickens' novels, including *A Christmas Carol*, were still selling splendidly at the time.

Eventually this country and much of the world would turn to folded Christmas cards. The Christmas postcard, and the single card which both preceded and followed it, would disappear from the holiday scene.

In 1939 a book entitled *The Christmas Companion* had perhaps a final say on the subject of the single Christmas card. Writing a chapter about the business of Christmas, author Rose Macaulay concluded:

"Everyone likes to receive those agreeable and bizarre picturettes. Those tokens of goodwill fly like birds from home to home, winging over land and sea, reminding us, alas, too often of those whom it were wiser to forget, and whom we have, in point of fact, forgotten. We all, I say, or nearly all, like to receive these charming objects—but how few of us like sending them."

Circa 1920s; $1-2.

Circa 1920a; $2-3.

Circa 1920s; $2-4.

Circa 1920s; $2-3.

Circa 1920s; $1-2.

Circa 1920s; $1-2.

Rust Craft
Circa 1920s; $1-3.

Circa 1920s; $2-4.

Circa 1920s; $4-5.

May Happiness

be yours at Christmas and in

The New Year

Circa 1920s; $2-3.

Circa 1920s; $2-4.

Christmas Greetings
and all good wishes for your happiness
in the New Year

Hearty Christmas Greetings and every
good Wish for the New Year

Hearty Christmas Greetings
and best wishes for
the New Year

Circa 1920s; $2-3.

Posted 1928; $1-3.

JUST HERE TO WISH YOU
A MERRY CHRISTMAS!

Merry Christmas

Circa 1920s; $3-4.

Circa 1920s; $1-3.

Circa 1920s; $1-3.

Hallmark
Circa 1920s; $5-7.

Circa 1920s; $2-4.

Circa 1920s; $2-4.

Circa 1920s; $1-3.

Merry Christmas and a Happy New Year

Posted 1928; $1-3.

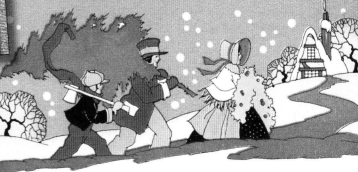

The House of the Singing Winds

The Seasons Greetings from Mrs. Theodore Clement Steele 1929

T.C. Steele
Dated 1929; $6-9.

Merry Christmas

Bringing in the Christmas tree
And hanging up the holly
Is lots of fun and may yours be
A Christmas bright and jolly!

Circa 1930s; $2-4.

There's a hearty wish from our house,
That is sent on its way to you:
May the Joyous Christmas spirit
Keep you happy the whole year through.

Circa 1930s; $1-2.

Many good Wishes for Christmas

With the heartiest greetings
And the best of good cheer
May your Christmas be merry
And bright your New Year!

Circa 1930s; $2-3.

Best and heartiest wishes for
a Merry Christmas
and a Happy New Year

Nannie Cohen

Circa 1930s; $3-4.

WITH THE CHEERIEST OF GREETINGS

AND WISHES MOST SINCERE

FOR A MERRY MERRY CHRISTMAS

A BRIGHT AND GLAD NEW YEAR

MADE IN U.S.A.

Circa 1930s; $3-4.

Circa 1930s; $3-4.

GREETINGS OF THE SEASON

May Santa, on his trip to you
See that all your dreams come true
Bring you many a Christmas treasure —
And a whole long day of
Christmas pleasure!

Circa 1930s; $6-8.

Circa 1930s; $3-4.

Buzza Company
Circa 1930s; $3-4.

With Best Wishes for a very Merry Christmas

Posted 1933; $2-3.

Christmas Greetings
When the holly gleams
And the candles shine,
I hope your Christmas
Is extra fine.

Posted 1933; $1-3.

Bibliography

Auld, William Muir. *Christmas Traditions*. New York: The MacMillan Company, 1931.

Denton, Clara J. *New Years to Christmas In Holiday Land*. Chicago: Albert Whitman & Co., 1930.

Golby, J.M. & A.W. Purdue. *The Making of The Modern Christmas*. Athens: The University of Georgia Press, 1986.

Hadfield, John. *The Christmas Companion*. New York: E. P. Dutton & Co. Inc. 1941.

McSpadden, J. Walker. *The Book of Holidays*. New York: Thomas Y. Crowell Company, 1958.

Reed, Robert & Claudette. *Vintage Postcards for the Holidays Identification & Value Guide, second edition*. Paducah, Kentucky: Collector Books, 2006.

Stevens, Patricia Bunning. *Merry Christmas! A History of the Holiday*. New York: MacMillan Publishing Co., Inc. 1979.

Stewart, Jane A. *The Christmas Book*. Philadelphia: The Griffith & Rowland Press, 1908.

Catalogs

Montgomery Ward Catalogue 1872, Golden Jubilee 1922, Chicago, Montgomery Ward & Co.

Index